THE FLOOD OF 2013

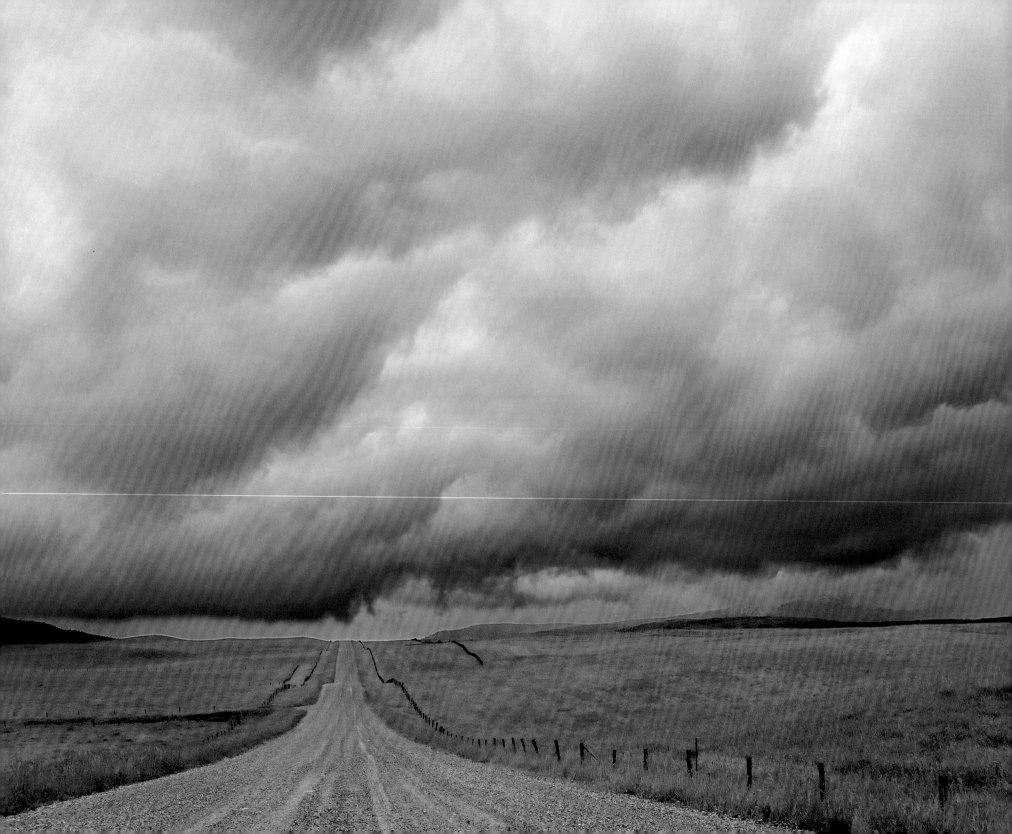

THE FLOOD OF 2013

A Summer *of* Angry Rivers *in* Southern Alberta

by the **CALGARY HERALD**

foreword by **NAHEED NENSHI**

GREYSTONE BOOKS

TORONTO/BERKELEY

FRONT JACKET PHOTOGRAPH A woman holds a young boy as they wait to place him on a combine that was being used to evacuate people stranded at the Co-op supermarket on 12 Avenue SE in High River, Alberta, on Thursday, June 20, 2013. (Stuart Gradon/*Calgary Herald*)

PREVIOUS SPREAD Storm clouds gathered near Waterton Lakes National Park on June 19, 2013, ushering in an intense rainstorm that hammered southern parts of the province the following day. Some areas of southern Alberta received more than 150 millimetres of rain in a twenty-four-hour period.

(Leah Hennel/*Calgary Herald*)

Greystone Books Ltd.
www.greystonebooks.com

Cataloguing data available from Library and Archives Canada
ISBN 978-1-77164-030-5 (cloth)
ISBN 978-1-77164-034-3 (pdf)

Edited and compiled by Monica Zurowski, Michele Jarvie, Chris Varcoe, Norma Marr, Lorne Motley, Debbie Penno, Ted Rhodes, Darren Francey, Tony Seskus and Valerie Fortney

Editing by Shirarose Wilensky
Jacket and interior design by Naomi MacDougall

Photography by Colleen De Neve, Stuart Gradon, Leah Hennel, Lorraine Hjalte, Tijana Martin, Ted Rhodes, Christina Ryan and Gavin Young of the *Calgary Herald*; Craig Douce of the *Rocky Mountain Outlook*; and David Moll.

For a full list of contributors, please see page 136.

Printed and bound in Canada by Friesens
Distributed in the U.S. by Publishers Group West

We gratefully acknowledge the financial support of the Canada Council for the Arts, the British Columbia Arts Council, the Province of British Columbia through the Book Publishing Tax Credit and the Government of Canada through the Canada Book Fund for our publishing activities.

Greystone Books is committed to reducing the consumption of old-growth forests in the books it publishes. This book is one step towards that goal.

CONTENTS

FOREWORD

By NAHEED NENSHI

WE WILL NEVER forget the summer of 2013.
There are images that are burned into my mind forever. Things I never thought I would see.

Some were awful.

I saw the Bow and Elbow Rivers—those rivers that run in the bloodstream of every Calgarian—run higher and faster and angrier than ever before.

I saw neighbourhoods under water and property ruined.

I saw broken streets and bridges and hearts.

But I also saw so much goodness. I saw the best of the human spirit. And I saw the best of public service.

I was out of town when it became clear I would need to authorize a local state of emergency. After managing the situation by phone in the early hours, I arrived back in Calgary late that evening. After an on-the-ground briefing, I needed to see our city.

That night, I drove with an incredibly patient and understanding police officer through the city. It was dark and quiet, most of the evacuations having been completed—the calm before the storm as we waited for the rivers to crest.

I held my breath watching the Bow River nearly touch the bottom of the Langevin Bridge. Even in the police vehicle, we could not enter large parts of Bowness that were already under water. And I knew from pictures and news reports of the pain and damage upstream and downstream—in Canmore and Bragg Creek, on the Siksika First Nation and in High River.

I spoke with incredibly tired guys who described themselves as "labourers" and were furiously bailing out the Glenmore water treatment plant to keep it, and our water supply, safe.

I met police officers, in the twentieth hour of their shift, who were evacuating senior citizens in the middle of the night. There was a language barrier, people were scared and confused, and it would have been very easy for the whole situation to have gone very badly very quickly. But my police colleagues treated those citizens with such professionalism, care and love that I knew at that moment we were going to be okay.

And in the ensuing days, I continued to see public service at its best. Colleagues at the waste water treatment plant who waded into the dark, fast water with pitchforks to save their plant. Folks who drove monster garbage trucks up and down streets to restore a bit of normalcy. Colleagues building a new road in one day and returning the CTrain to service in unbelievable time. We're blessed to have them all.

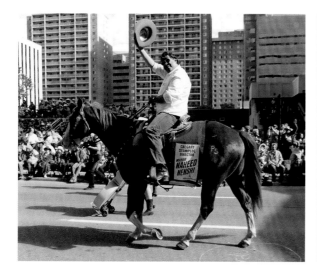

Certainly, I also thank the federal and provincial public servants—including full-time and reserve members of the Canadian Forces—for all they did and continue to do.

The most enduring image of the flood, though, is that of the ordinary citizen—covered head to toe with mud and mosquito bites, cut and scraped and bruised—working hard to save the home of someone she doesn't even know.

Every one of us figured out how to use our own hands, hearts and minds to help our neighbours.

Why? Because it's what we do.

I'm knocked to my knees every time I think about that sign in Bowness put up by a family that had its home completely gutted. "We lost some stuff; we gained a community." This story repeats, hundreds and thousands of times, across the city and the province.

I once asked a volunteer if she was affected by the flood.

"I live in Forest Lawn," she told me. "My neighbourhood didn't see any water. My basement is dry. But, Mayor, we were all affected by the flood."

We did a good job of rebuilding quickly. It's almost unbelievable that we had the Stampede, that we enjoyed the Folk Festival. But much remains to be done, in Calgary and around southern Alberta. So thanks to the *Calgary Herald* for putting together this book and giving people another chance to help.

The floods reinforced that we, as a community, can do amazing things. That we can show so much compassion and give so much of our resources to friends and neighbours, whether we know them or not. We, as Calgarians and southern Albertans, should be proud of what we have accomplished together.

Because it's what we do.

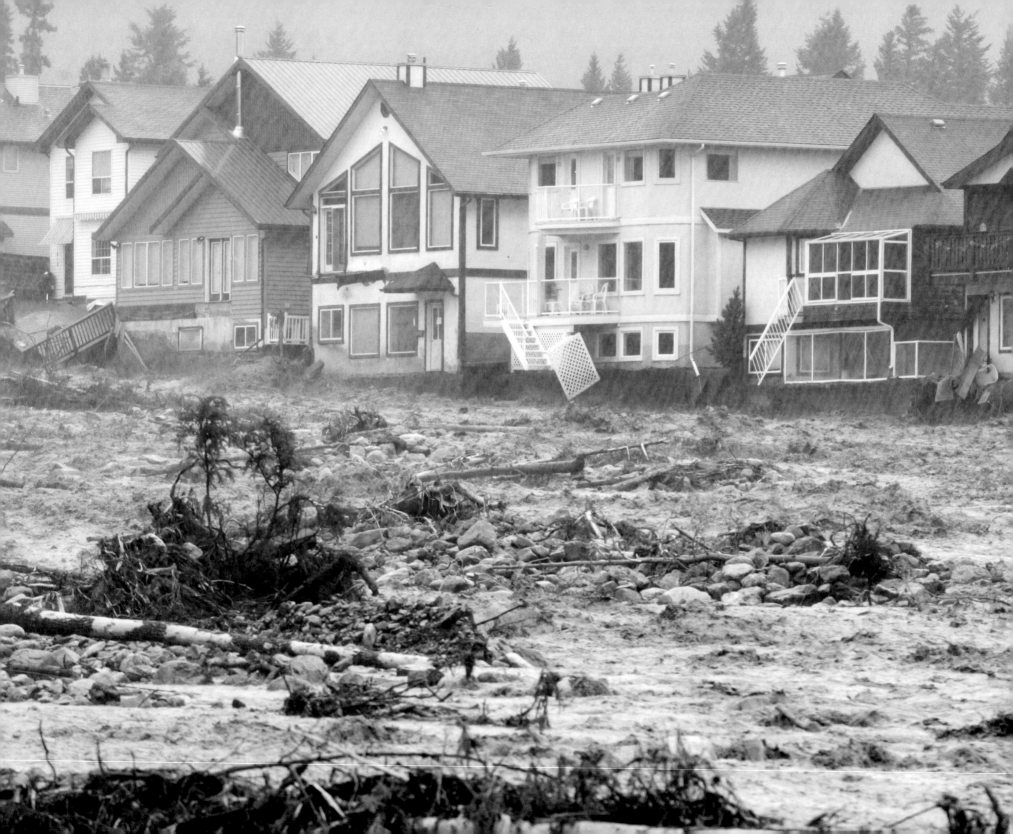

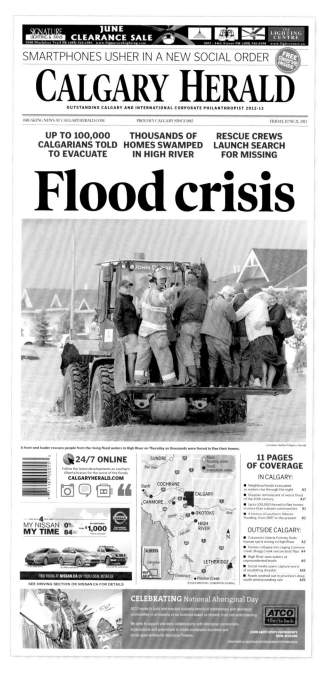

FACING PAGE As the rain came down, the water flowing into rivers and creeks throughout southern Alberta surged. In Canmore, homes along Cougar Creek were battered by flash flooding on the morning of June 20. Trampolines, wooden decks and logs floated down the raging creek, and homes were left teetering along its widening banks.

(Craig Douce/Rocky Mountain Outlook)

1 / THE RAGING WATERS

Compiled by **TONY SESKUS**

CALGARY'S CONNECTION WITH the water is both old and deep. The city's very origins can be traced to the confluence of two rivers—the Bow and Elbow—which have carved ancient, meandering channels from the Rocky Mountains to the foothills and out to the boundless Canadian Prairies. Since 1875, generations of Calgarians—whether they were living in a lonely Mountie outpost, a pioneer town or a bustling city—have long depended on the rivers for life, leisure and commerce. It's a shared dependence across southern Alberta, where early settlers established thriving

communities such as High River, Canmore and Medicine Hat alongside such vital tributaries.

But for all the blessings the rivers bestow, there are dangers. Floods are an old and fearsome foe. Albertans have chronicled many tales of the times when roiling waters broke riverbanks, washed over communities and filled homes with heartbreak. Yet people have rallied to regroup, rebuild and forge ahead—whether it was in 1897, 1932, 1950 or 1995. It's a history of resilience; some might say foolhardiness.

Still, little in the past could have prepared Albertans for what they'd face, beginning on the final days of spring of 2013. A sudden mountain deluge released a mighty cascade that would reshape the landscape, ruin homes, cause billions of dollars in damage and take five lives. But the flood—the largest in provincial history—also released a wellspring of compassion. And like past generations, many Albertans are again determined to show that tales of fortitude and kindness will be this disaster's real legacy.

"I've seen things I never thought I would see: the Bow and Elbow Rivers, part of the bloodstream of every Calgarian, running higher and faster and angrier than ever before, entire communities under water, and neighbours who lost nearly everything they owned," Mayor Naheed Nenshi wrote in the *Herald* in the weeks after the June 20 flood. "The enduring image for me of the floods," Nenshi continued, "a simple one, repeated so many thousands of times: the picture of that Calgarian, covered in mud and mosquito bites, marked with cuts and scratches and bruises, working to save the home of someone she doesn't even know. It's an extraordinary story, and it's something none of us will ever forget."

The trouble, as it often happens in Alberta, began overhead: a giant low-pressure system came over the mountains from the Pacific—and promptly got stuck in a loop of the jet stream. As the system spun and stalled over the foothills, it sucked in moisture from Saskatchewan, the United States and the Gulf of Mexico. Starting around suppertime on June 19, it began to rain. It poured for fifteen to eighteen hours straight across most of southwest Alberta. Over an intense twenty-four-hour period, more than 150 millimetres of rain pelted a swath of southwestern Alberta, from just north of Banff to the U.S. border, with a bull's eye settling near the town of High River.

"It was like this fire hose of moisture," Chris Scott, chief meteorologist at the Weather Network, explained to Postmedia News. The weather system just kept slamming precipitation into the mountains. And it wasn't just one area that got hit. Rain covered the entire Bow River basin—the headwaters for all the rivers that flow into the

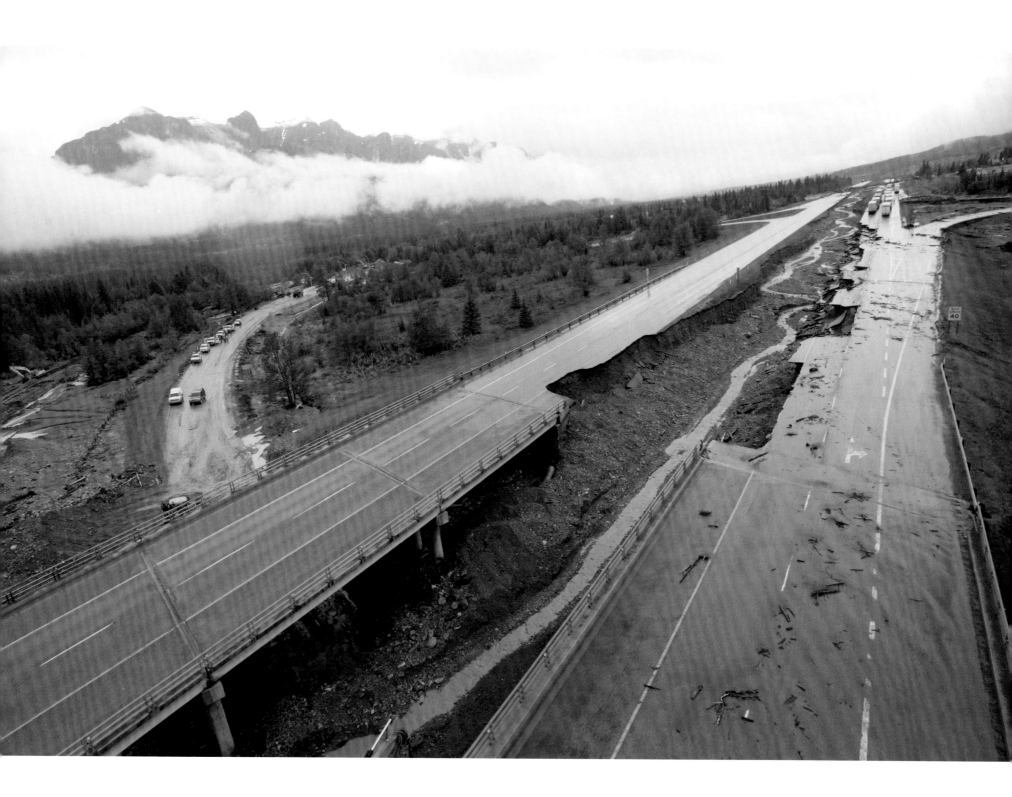

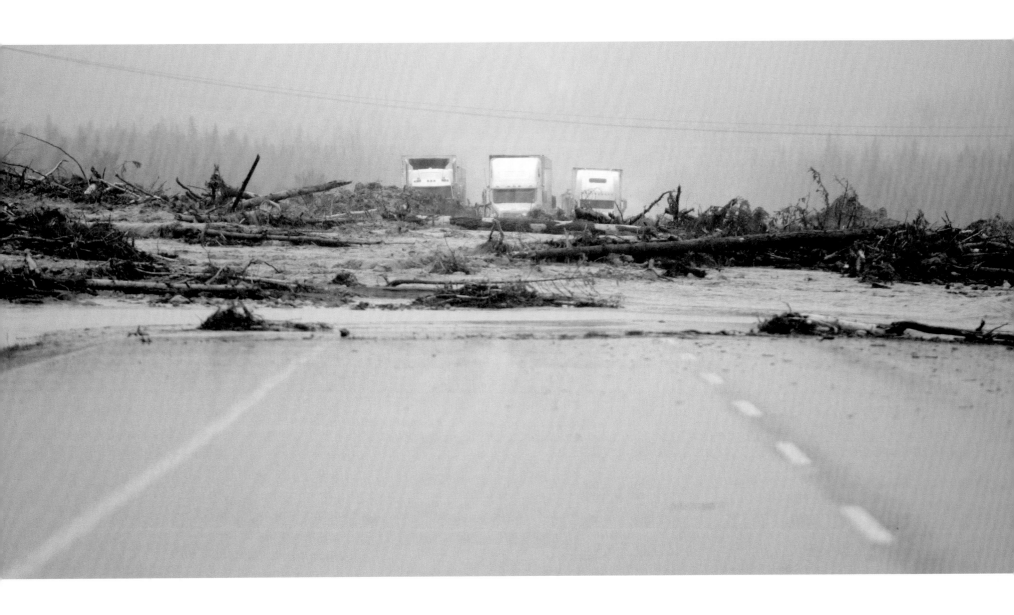

FACING PAGE Debris and water poured across the Trans-Canada Highway near Canmore, severing the national highway and stopping traffic for days. Mudslides also closed parts of the highway in Banff National Park.

(Craig Douce/Rocky Mountain Outlook)

Bow and Elbow before they get to Calgary. Making matters worse, little of the moisture fell as snow. And where there was snow, the rain melted it, adding to the volume of water collecting in streams and rivers. It was the worst kind of luck. "Rain on snow is a miserable thing because it washes the snow away; your problems are that much worse," said Dan Kulak of Environment Canada.

On the mountains and foothills of southwest Alberta, the weather forecast played out with dire results. The rain came down so furiously that the earth couldn't absorb it. Within a matter of hours, families had to scramble from their warm beds and flee for safety. Among the first to face the danger were residents of Exshaw and Canmore, two neighbouring communities just a short drive from the gates of Banff National Park.

Typically, Cougar Creek merely babbles as it winds its way past some of the scenic streets of Canmore, an old mining town turned thriving mountain retreat. But in the early hours of Thursday, June 20, Cougar Creek was "rumbling and groaning," said Wade Graham, who was stirred from his sleep by the frightening noise. Anyone venturing out to see what was happening was awestruck: rocks and trees, hot tubs and decks, mud and water—unfathomable amounts of water—raced past in the once-gentle stream. As the creek banks became unstable, nearby residents packed up what they could and headed for higher ground.

Just fifteen kilometres to the east, Exshaw's quiet creeks were turning into monsters. Volunteer firefighters scrambled to the fire hall around 2 AM. One of the streams, Jura Creek, had breached its banks. It was time to evacuate. Residents, who went to bed hours earlier with no idea that anything was amiss, were soon being helped by firefighters through chest-deep rushing water. It was a surreal scene: the power was out, sirens squawked and car alarms shrieked as rising water shorted out their electrical systems. Mandie Crawford, a volunteer firefighter, later described the harrowing evacuation—including her own struggle to propel herself from house to house alerting residents. "You can't see your footing; you can't even feel your footing. And if you fall, you're gone, because the weight of the suit will pull you down," she recounted. Fortunately, no one was sucked into the rushing water and no lives were lost in the community of almost four hundred souls. Sadly, the same couldn't be said elsewhere.

As some Bow Valley residents began to head for high ground, a desperate situation was developing near Longview, a historical ranching village about eighty kilometres south of Calgary. On June 19, Amber and Scott Rancourt had set up a campsite among the tall trees on the west side of the Highwood River after deciding to spend the weekend on a friend's ranch. The young couple arrived with Diesel, a horse Amber had saved from near starvation in Ontario.

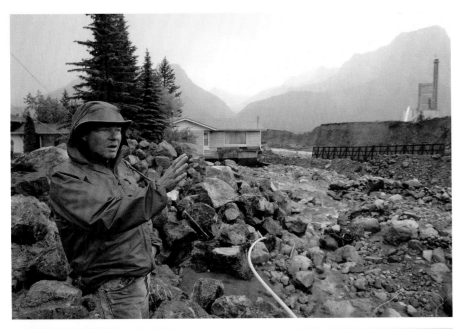

They set up their camper several metres away and up from the riverbank. A lightning storm rolled overhead, but they weren't worried. There had never been a flash flood in this area. Around 1:30 AM on June 20, Scott checked the river. It was up several centimetres, but nothing hinted at the fury headed their way. Two hours later, the river was cresting its banks. Soon, water was up to the camper door.

Scott and Amber called friends to see if they could drive a tractor to rescue them, but the mighty river had carved an island around the pair. Worried for their horse, the couple decided to get Diesel to higher ground. Telling Amber he'd see her shortly, Scott waded into waist-deep water and led the big horse west to where he could spur Diesel into the river and across to safety. But as Scott pushed his way back to Amber, who was still in the camper, a wall of water as high as his chest hurtled him downstream. The river was packed with logs and debris that battered the rancher. For more than three hours, he fought to get back to the trailer, but it was now wedged in a cluster of trees. While a search helicopter plucked him to safety, Amber was nowhere to be found. In the daylight, from a helicopter he later hired, Scott spotted his wife's limp body among a stand of trees. The aircraft touched down in the only dry spot. Using a chainsaw, he cut away the branches and carried her out in his arms. The flood of 2013 had claimed its first victim.

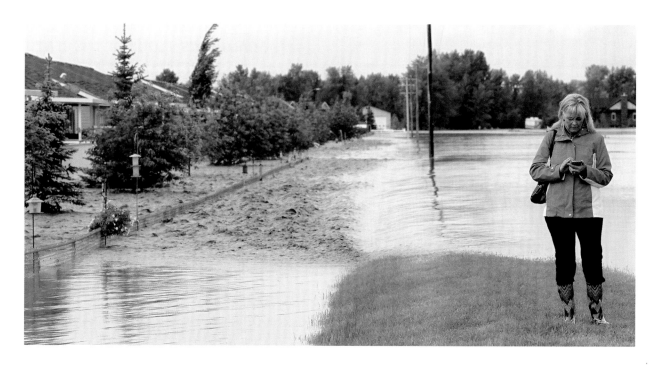

As the water from Highwood River surrounded High River, Christine Welke checked on the back of her home.

(Lorraine Hjalte/*Calgary Herald*)

Calgarians woke up the morning of June 20 to see the staggering images from Canmore. Alberta flood news was already trending on Twitter with pictures and video of unimaginable scenes. Raging rivers swallowed up yards and devoured decks. Torrents of water lapped hungrily at exposed foundations, with homes teetering on the brink of being swept away. Bridges were washed out. Highways closed. Mudslides swept across roadways. Traffic on the busy Trans-Canada Highway came to a standstill. "People are scared and anxious," declared Canmore resident Dr. Tracy Thomson. "We're isolated. We can't go west to Banff. We can't go east to Calgary."

For people living east of Canmore, the terrifying images on news websites, Facebook and Twitter added up to one worrying conclusion: trouble was headed downstream. By 5:30 AM, rapidly rising water levels were reported in the Black Diamond and Turner Valley areas. Voluntary evacuations of low-lying areas went into effect. Shortly after 7 AM, High River officials declared a state of emergency as the Highwood River began overflowing its banks. Residents in the town's Wallaceville area were encouraged to evacuate, while campers in George Lane Park were told to leave. Yet there was little sense of panic. The community, as its name might suggest, had battled flooding many times. There was almost a routine to it. Residents were told that sandbagging was to begin within an hour. An evacuation centre was set up. People went to work. Children were dropped off at school.

It wasn't long before residents realized the situation wasn't routine at all. By 9:20 AM, the northwest, southwest and northeast areas of High River were under mandatory evacuation. Residents in the Vista Mirage area were already stranded by high water. Twenty-five

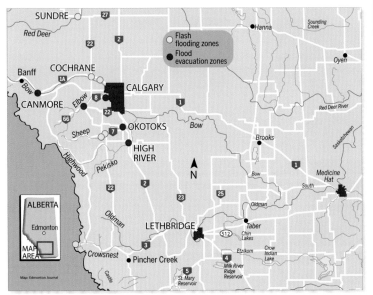

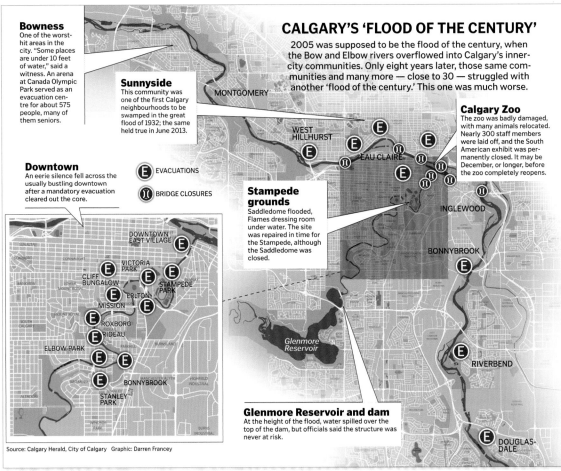

CALGARY'S 'FLOOD OF THE CENTURY'

2005 was supposed to be the flood of the century, when the Bow and Elbow rivers overflowed into Calgary's inner-city communities. Only eight years later, those same communities and many more — close to 30 — struggled with another 'flood of the century.' This one was much worse.

Bowness
One of the worst-hit areas in the city. "Some places are under 10 feet of water," said a witness. An arena at Canada Olympic Park served as an evacuation centre for about 575 people, many of them seniors.

Sunnyside
This community was one of the first Calgary neighbourhoods to be swamped in the great flood of 1932; the same held true in June 2013.

Downtown
An eerie silence fell across the usually bustling downtown after a mandatory evacuation cleared out the core.

Calgary Zoo
The zoo was badly damaged, with many animals relocated. Nearly 300 staff members were laid off, and the South American exhibit was permanently closed. It may be December, or longer, before the zoo completely reopens.

Stampede grounds
Saddledome flooded, Flames dressing room under water. The site was repaired in time for the Stampede, although the Saddledome was closed.

Glenmore Reservoir and dam
At the height of the flood, water spilled over the top of the dam, but officials said the structure was never at risk.

E EVACUATIONS

II BRIDGE CLOSURES

Source: Calgary Herald, City of Calgary Graphic: Darren Francey

minutes later, town officials used Twitter to put out an amazing request: "We need a small riverboat to help evacuate #Highriver residents." Soon, the first schools began to evacuate. Although people on the ground couldn't see it, an enormous pool of water was rapidly, silently enveloping block after block of the town.

Chris Beierling got a call from her neighbour around 9 AM. At that point, she looked out the window and saw water coming up the driveway. By the time she phoned her husband, it was coming through the garage doors. All over town, the situation rapidly deteriorated. Adults and children were evacuated to Highwood High School, but by afternoon, it had to be evacuated as well. Adding to the chaos, cellphone service became erratic, making it difficult for people to check on loved ones. Four *Herald* journalists were caught out by the flash floods and forced to abandon their vehicles. Videographer Rick Donkers, who hitched a ride to safety aboard a massive combine recounted one of the harrowing scenes he witnessed that day as the driver of a small car tried to escape across a street that had turned into a river:

24/7 ONLINE
Follow the news today as southern Alberta battles the floods.
CALGARYHERALD.COM

CALGARY HERALD
OUTSTANDING CORPORATE PHILANTHROPIST 2012

BREAKING NEWS AT CALGARYHERALD.COM **WEEKEND EDITION** SATURDAY AND SUNDAY, JUNE 22-23, 2013

SPECIAL EDITION: THE FLOOD OF 2013

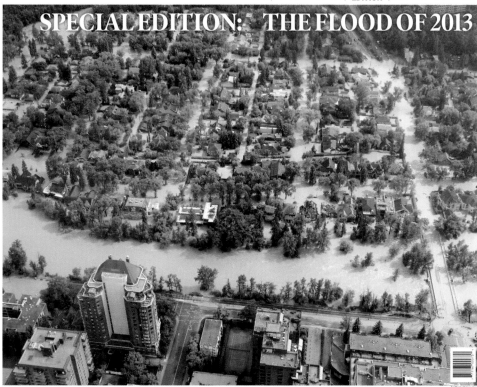

A swollen Elbow River swamps the inner-city community of Roxboro east of 4th street. Both the Elbow and Bow rivers breached their banks on Friday. Ted Rhodes/Calgary Herald

> " The water isn't supposed to look
> like this. This is an incredible event.
> — PRIME MINISTER STEPHEN HARPER
> SEE STORY, PAGE A5

CALGARY HERALD
OUTSTANDING CALGARY AND INTERNATIONAL CORPORATE PHILANTHROPIST 2012-13

BREAKING NEWS AT CALGARYHERALD.COM PROUDLY CALGARY SINCE 1883 MONDAY, JUNE 24, 2013

THE FLOOD OF 2013

'WE WILL LIVE
WITH THIS FOREVER'

PREMIER ALISON REDFORD

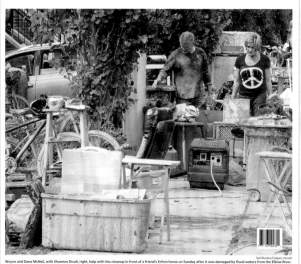

Wayne and Dana McNeil, with Shannon Divall, right, help with the cleanup in front of a friend's Erlton home on Sunday after it was damaged by flood waters from the Elbow River. Ted Rhodes/Calgary Herald

16 PAGES OF FULL COVERAGE

 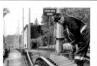

MEDICINE HAT	**DOWNTOWN**	**INGLEWOOD**
Community 'optimistic' as it braces for South Saskatchewan River to crest	Schools, inner-city office towers to remain quiet as workweek begins	Neighbours lend a hand to those at risk of seeing houses washed away
Page A4	Page A3	Page A11

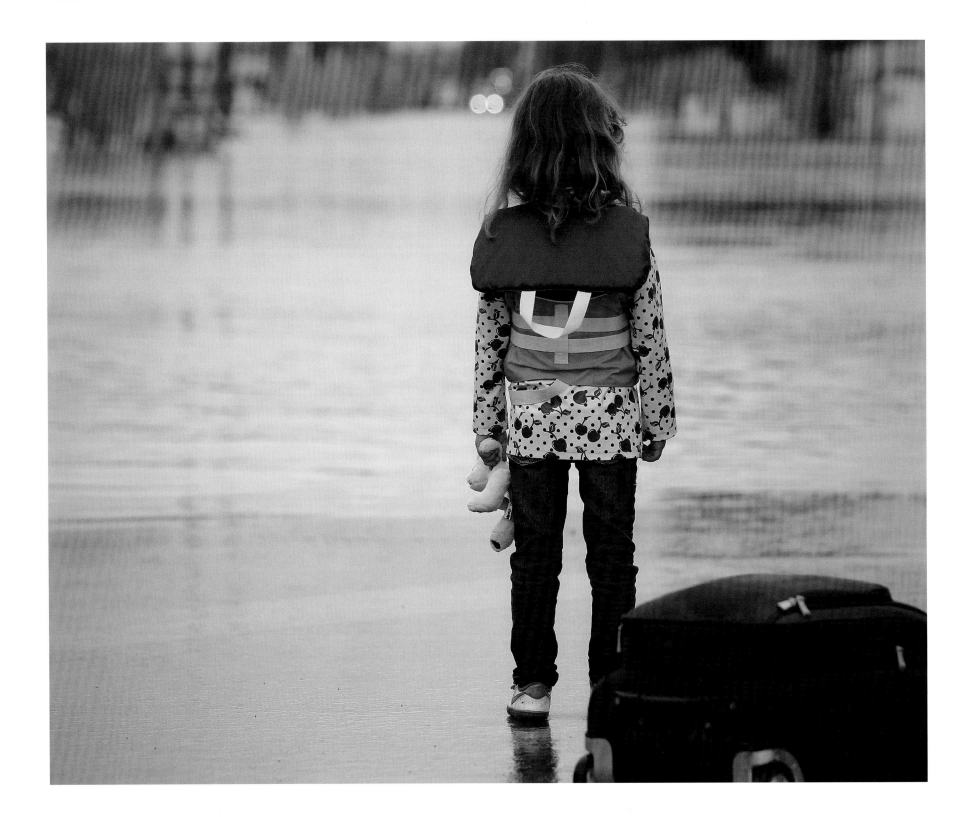

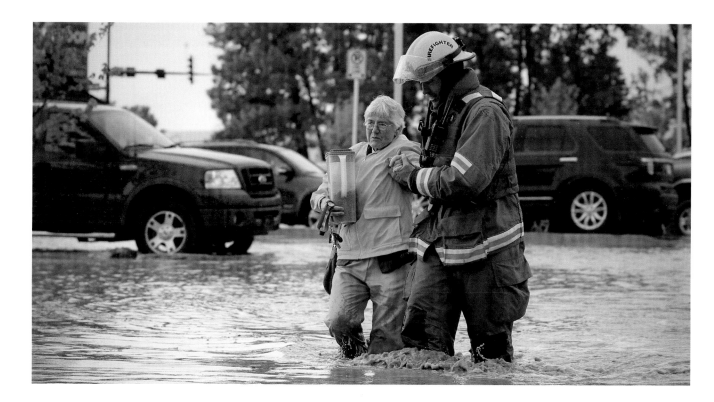

"My colleague David Fraser and I were slowly walking towards 5th Street in the hope of grabbing a ride across the fast-moving flow on one of the trucks waiting their turn to cross the newly formed river. We watched a few 4 × 4s race against the growing current—each run appearing a little more dangerous. Then we saw a silver Kia. Next to the pickups, it looked puny. It lunged forward to cross the torrent but hit the fast-moving water with a thud. The powerful current whipped the car over a curb and into some bushes. It looked as if it might flip. The three people inside quickly scrambled out. Then I saw a passenger fall into the water and get swept downstream. His body was thrown against a wrought-iron fence. Only his head was above water. All around me, onlookers surged forward to help. There were calls for ropes—anything to assist. Two young men handed me their phones for safekeeping as they went in the water to help. A rope and jumper cables were being tied together. The man could barely move in the water. The current was so strong. His face gripped with fear—obvious to all that he was about to die. It seemed certain he'd soon be swept away. He turned and began to work his way—hand over hand—along each fence picket. The crowd yelled at him to go the other direction to safety. He yelled that the stream was too strong but then reconsidered. Grabbing each baluster of the fence along the way, the look of terror slipped from his face. He was eventually met by rescuers in the waist-high water and shuttled to safety. There would be no more vehicles attempting that crossing."

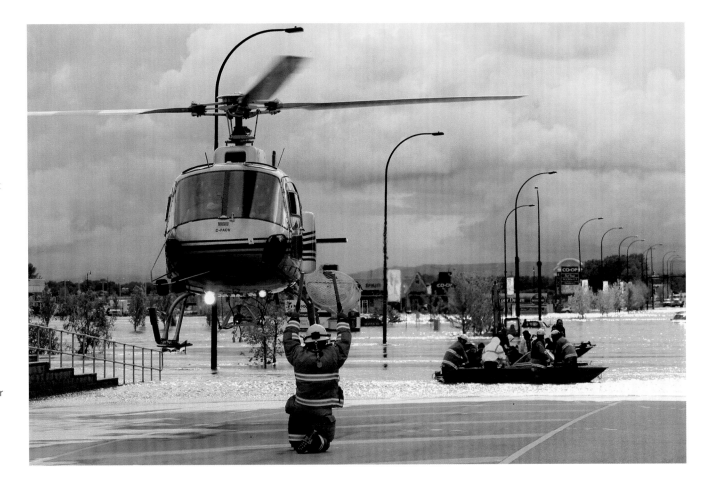

RIGHT All of High River's residents faced evacuation orders by mid-morning on June 20. Steady streams of people were rescued by boat and helicopter after the Highwood River left part of the town under water. By the following day, RCMP reported 150 people had been rescued from rooftops.

(Lorraine Hjalte/*Calgary Herald*)

FACING PAGE LEFT Rescuers brought this woman to safety after reaching her with a boat as the waters of the Highwood River continued to climb.

(Lorraine Hjalte/*Calgary Herald*)

FACING PAGE RIGHT An emergency services member waded into the flood water near 12th Avenue SE in High River on June 20. (Stuart Gradon/*Calgary Herald*)

Similar scenes played out across the town of thirteen thousand, less than an hour's drive south of Calgary. As the rushing river penetrated streets, parks and buildings, long-time residents were astonished by what they saw. Homes and businesses were swallowed up. Helicopters plucked dozens of people from rooftops. Zodiac boats streaked across town. Huge front-end loaders and large combines ferried people to safety. Communities thought to be safe from flooding were three metres deep in water. This flooding was unprecedented. "You live in High River, you get used to flood season. But this? I've never seen anything like it in my life—it's left me speechless," said Cheryl Beingssner-Kerr.

By day's end, much of the town was under water as the entire community faced mandatory evacuation—though some people refused to leave.

Amidst all of the chaos and confusion, there were also moments of courage and compassion. Wayne Goodman and his brother got in

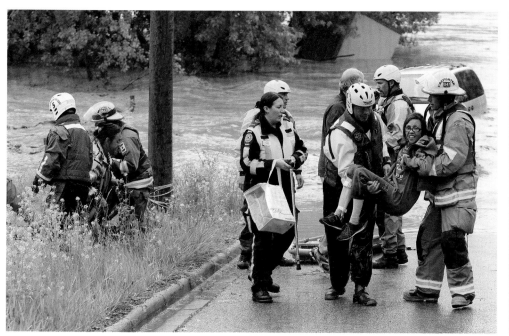

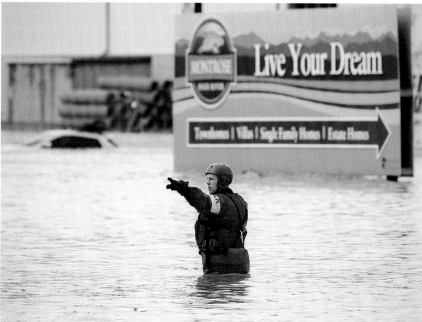

a canoe and rescued a dozen stranded folks, including children. Resident Dave Pawlitzki, who works as a Calgary paramedic, laboured non-stop for hours rescuing neighbours. Chris Beier, a twenty-three-year-old welder, dove into the flood waters to help save a cat named Momo, gaining national attention when a photographer captured the pet's desperate swim for safety. Nearby communities such as Nanton and Blackie opened their arms to evacuees, and Hutterite colonies stepped up with volunteers and food.

Among the heroes in High River was thirty-three-year-old Jacqui Brocklebank. Born with cerebral palsy, she'd fought hard to lead an independent life. She was also someone who put others first. It wasn't surprising when Brocklebank called her boyfriend on June 20 to say she was going to check on a friend who lived in a basement suite on the town's east side. After arriving by taxi late

that morning, Brocklebank pounded on her friend's door to wake her up and then headed downstairs. In the time it took her friend to get dressed, there was so much water entering the suite that items were floating about. Brocklebank was pinned by a suddenly buoyant refrigerator, but her friend pulled her free. Outside, the streets ran fast with water. The two friends clasped hands and tried to fight the current together, but the torrent pulled them apart. Brocklebank was knocked into the muddy, rushing water by an errant trailer and swept underneath the structure. She did not survive. "She was doing what she loved to do and that was help people," her mom, Janie Pighin, later told the *Herald*. "She went back into the flood to help her friend. We're so proud of her."

All around southern Alberta that day, communities were rocked by the effects of hemorrhaging river systems. In the southwest corner

FACING PAGE By the evening of June 20, people were still being plucked from their homes in Montrose, a new neighbourhood on the south side of High River. Wayne Goodman, a Montrose resident, spent part of the following day in a canoe, helping rescue about a dozen people. "Nobody was prepared for this," said Goodman. "The system didn't work. It failed."

(Lorraine Hjalte/*Calgary Herald*)

of the province, flash floods washed out roads in the Crowsnest Pass and Lethbridge County. Families on the Stoney Nakoda Nation near Morley, about sixty kilometres west of Calgary, were flooded out. In Black Diamond, the water treatment plant was obliterated and the vital link connecting the town to nearby Turner Valley—the Sheep River Bridge—was swamped. Turner Valley residents also had a scare after a cascade of trees and mud from the flooding ruptured a sour gas pipeline. Fortunately, only a small amount of the potentially toxic hydrogen sulphide was released into the air and the problem was soon fixed. Further northwest of Turner Valley, close to six hundred residents were forced to flee from Bragg Creek, where businesses at the well-known shopping mall were overrun by a torrent of mud and water.

Then, overnight, the storm claimed a third life. Rob Nelson, a forty-one-year-old father of six, had already spent much of June 20 and the early hours of the following day building berms and pumping water from homes near his acreage east of Okotoks. A devout member of the Church of Jesus Christ of Latter-day Saints, he believed in helping others. Before 6 AM on June 21, shuttling between neighbours in need, Nelson lost control of the quad he was driving. The vehicle rolled and he struck his head on the pavement. Escorted to the accident scene by police, Nelson's wife, Jennifer, told her dead husband she loved him and would see him again in eternity. She gave him one last kiss. "It was a beautiful moment," Jennifer said.

The forces of nature ruled the day. But at Redwood Meadows, a small community west of Calgary, a contingent of residents, volunteers and members of the Tsuu T'ina Nation mounted a remarkable defence of the townsite. "I'd say we were within an hour of losing all of it," Mayor John Welsh said. "We would have been gone. And I don't mean gone to the point that we lose a couple of homes. The river would have come through and taken the community away with it."

Redwood Meadows has about 1,250 residents living in 351 homes built on Tsuu T'ina Nation land, wedged against the Elbow River. As the rains started falling heavily on June 19, Tsuu T'ina enacted its disaster plan. "The flooding just crept up on everyone so quickly," said Chief Roy Whitney. By 9:30 AM on June 20, most residents were sandbagging to protect their homes. But sandbags weren't going to be enough.

"We knew pretty quickly we were in a lot of trouble, and we made a lot of calls to a wide variety of people. The nation stepped up pretty quickly," Welsh said. Tsuu T'ina's road management team drove in several dump trucks and gravel and began reinforcing an eroding

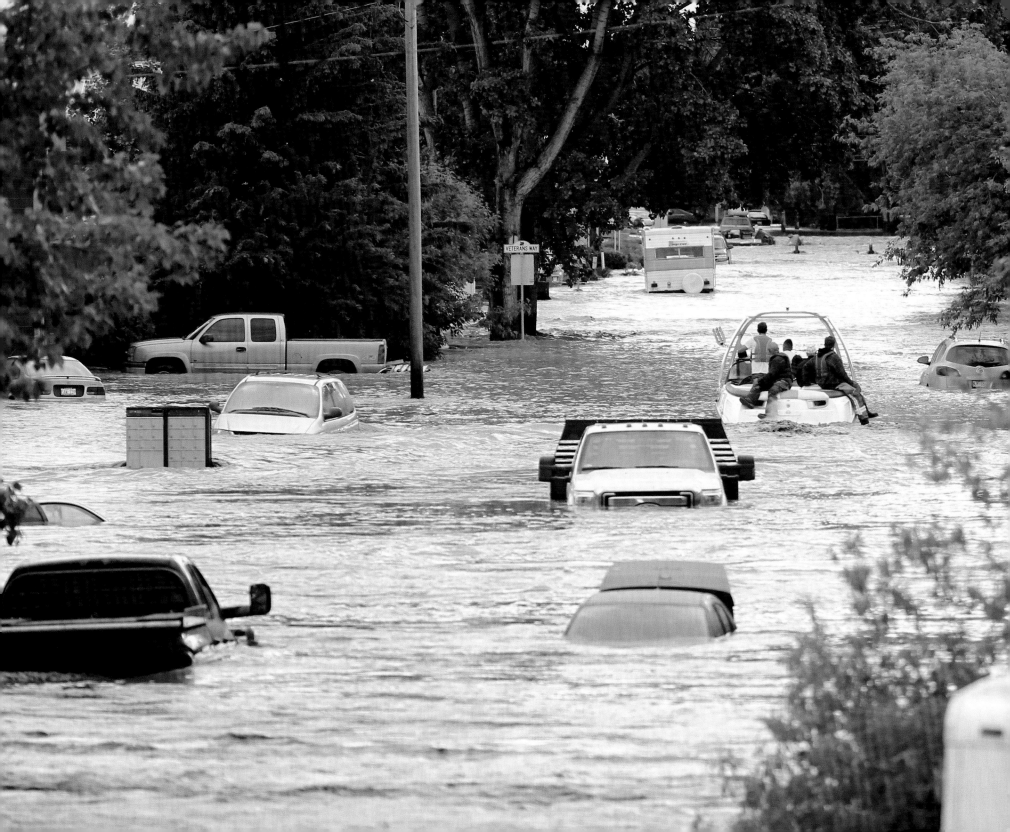

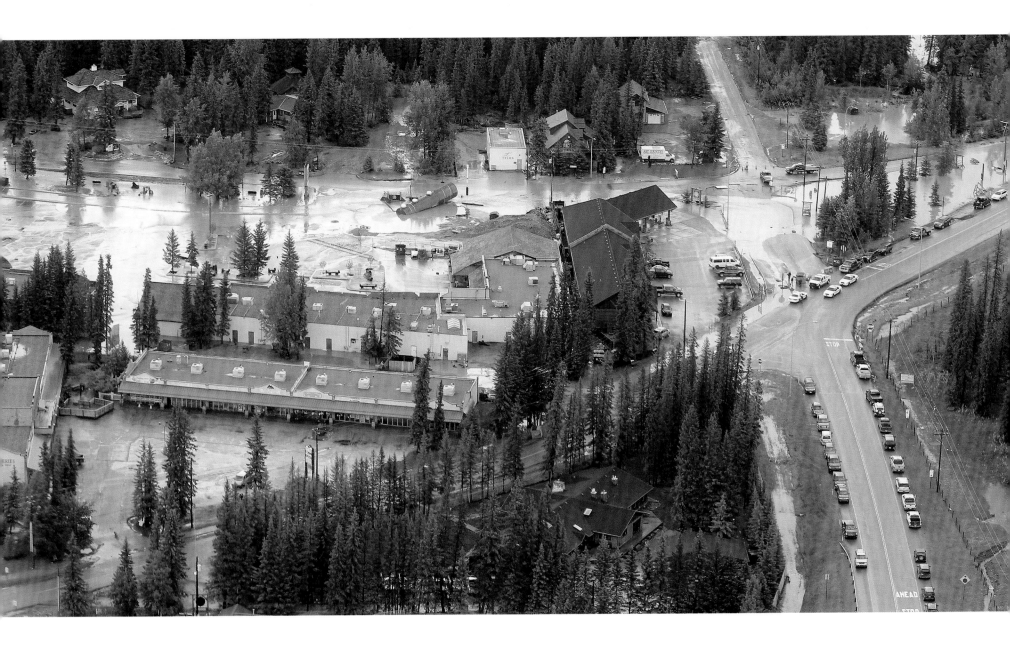

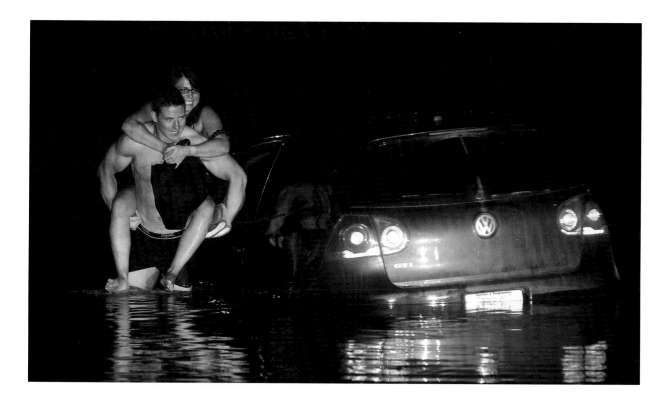

As the rain began to fall in the Rockies on Wednesday night, Calgary's mayor was beginning a whirlwind tour of Ontario. Early in the morning of June 20 in Toronto, Nenshi's attention was drawn back to Calgary. There were numerous tweets, texts and emails about heavy rain, mudslides and broken highways just outside Calgary—and the flood waters were headed toward his city. The city's municipal emergency plan was activated, and Calgary's new emergency operations centre was opened at 8:30 AM. At the Toronto hotel where he was speaking, the mayor rushed into a downstairs room for a phone call with city officials. Although the cellphone reception was poor, one point from Fire Chief Bruce Burrell came through loud and clear: "This is going to be really, really bad." At 10:16 AM, the city declared a state of local emergency and crews began to sandbag in low-lying areas near the Elbow and Bow rivers. Already, officials were fearful events would be worse than in 2005, when major flooding damaged forty thousand homes and forced fifteen hundred people to evacuate.

berm. Emergency services, the Tsuu T'ina, a contractor and Redwood Meadows volunteers worked throughout the day. They fought the river until 4 AM, but then they had to evacuate. Two hours later, Welsh and emergency services went back at it. "We didn't think we had much hope. But Tsuu T'ina showed up pretty much right away when they found out that we were still here," he said. And then, another godsend arrived—a local resident donated more trucks. Together, the crews dumped about 170 loads of gravel on the berm. By the evening of June 21, they thought they had a handle on things. But by the next morning, the berm behind Welsh's house had disappeared. Once again, everyone pulled together and ultimately saved Redwood Meadows from the Elbow River's wrath. The berms held.

TOP RIGHT A wet dog was kept warm while it—and its owner—awaited evacuation from a flooded parking lot in High River. (Stuart Gradon/*Calgary Herald*)

BOTTOM RIGHT More than 100,000 Albertans faced evacuation because of the 2013 flooding. At the Tom Hornecker Recreation Centre in Nanton on June 21, victims caught up on some sleep after a long, emotional day.

(Stuart Gradon/*Calgary Herald*)

FACING PAGE Bragg Creek and communities near the Rocky Mountains were also hammered by flooding. The distinctive Bragg Creek Trading Post was almost submerged by the overflowing waters of the Elbow River on June 21. (Ted Rhodes/*Calgary Herald*)

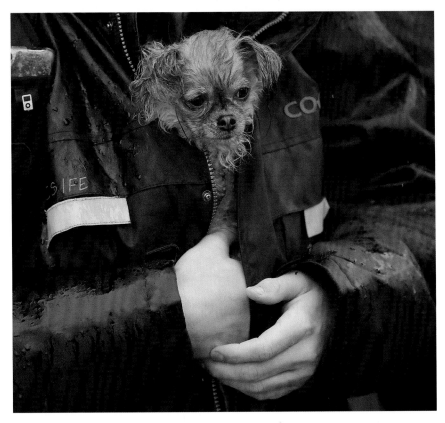

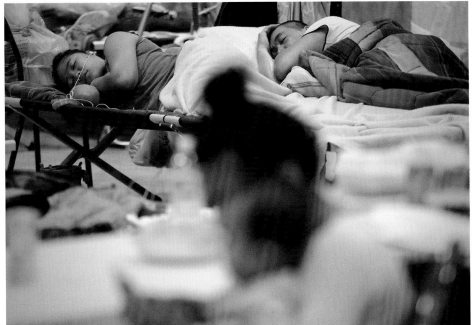

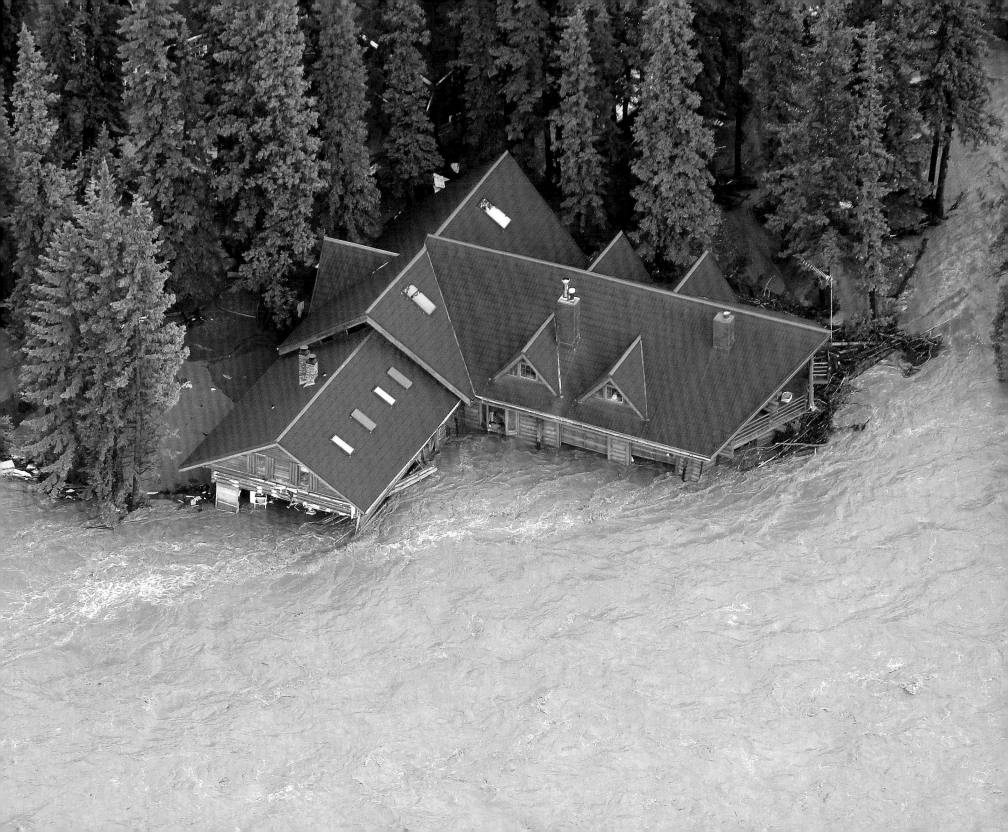

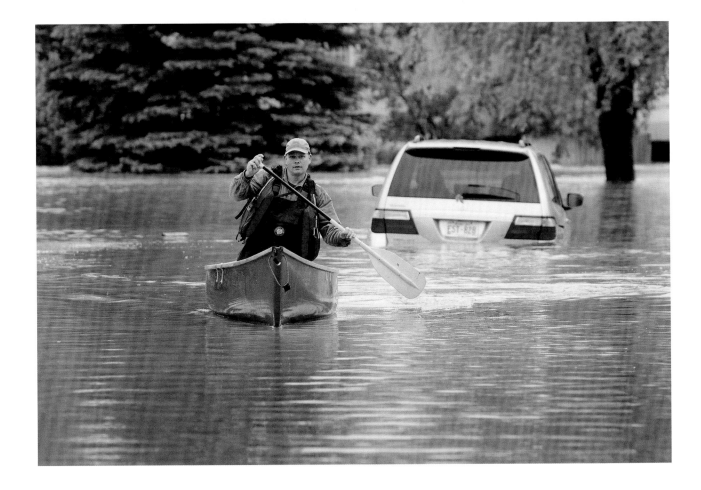

Throughout that day, water levels along Calgary's rivers continued to rise. The Calgary Zoo shut its doors. Berms were built. Just after 2 PM, the first communities were told to evacuate—Mission, Elbow Park, Stanley Park, Roxboro, Rideau and Discovery Ridge. Within twenty-four hours, residents from more than twenty neighbourhoods were told to leave their homes, affecting roughly 110,000 people. It was a surreal scene as police and fire department vehicles cruised the streets, using loudspeakers to warn people to get out. To accommodate the growing number of evacuees, the city opened five reception centres. Amazingly, only fifteen hundred people would ultimately use the shelters, because fellow Calgarians took in most of the evacuees. As thousands of people packed up their belongings, city crews and emergency personnel worked into the night to prepare for the floods. By 10 PM, the inflow into the Elbow River was forty times the normal rate. Water began to spill over the top of the dam on the Glenmore Reservoir before midnight. And with the river

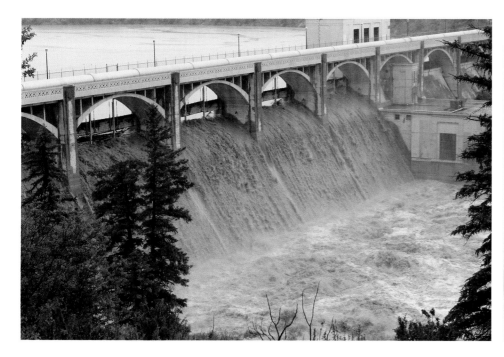
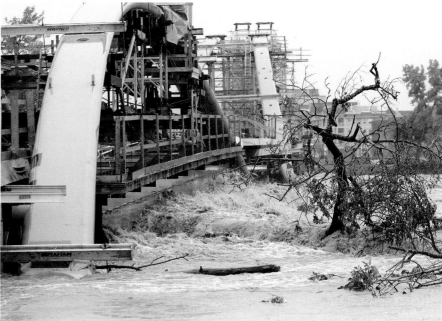

flows expected to peak overnight, Calgarians braced for the worst… and got it.

As night fell across the city, water washed over Calgary streets, parks, schools, businesses and homes. Flooding reached the Saddledome, the Stampede grounds and the zoo. Staff at the Glenmore Dam worked hard to pump water out of the subfloors so that the treatment plant could continue to function properly.

As the water in Mission rose and swallowed the neighbourhood, one resident was in trouble. When police swept through the streets during the mandatory evacuation of the inner-city community on June 20, eighty-three-year-old Lorraine Gerlitz gave every indication of leaving. Gerlitz assured police and friends that she was making her way to higher ground with her beloved cat, Lucy. But for reasons unknown, Gerlitz never made it out, becoming Calgary's only flood-related fatality. "Certainly this is a tragedy for the family, for the friends, for the neighbours of the woman who has passed away," Nenshi said in the following days. "It's a tragedy for all of us."

Late on June 20, Nenshi returned to Calgary and toured the front lines of his city's battle with the rivers. He was astonished by the speed and power of the water. In the dark, the mayor headed downtown in a police SUV, crossing the Centre Street Bridge and continuing over to the Langevin Bridge, where he saw water already lapping at its bottom. Then he travelled by the nearby Peace Bridge spanning the ferocious Bow, where Nenshi got out to survey the situation. "I stood there on the pathway. It was so dark, and the river, it was terrifying," he said. In the neighbourhood of Bowness, on Calgary's western flank, he spotted Mary's Corner Store—a community staple—with water skimming its door. Soon, large swaths of the

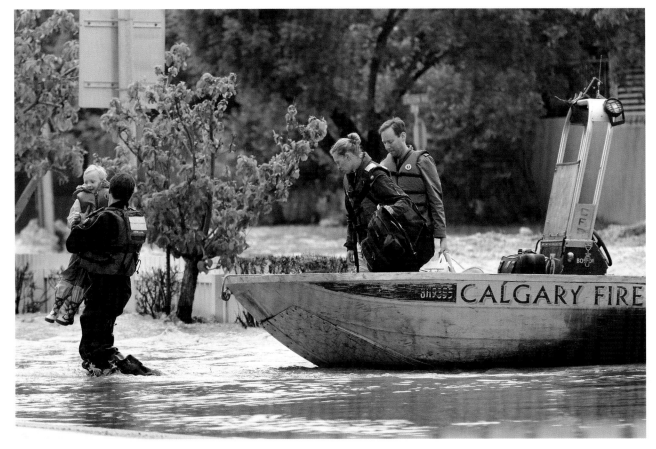

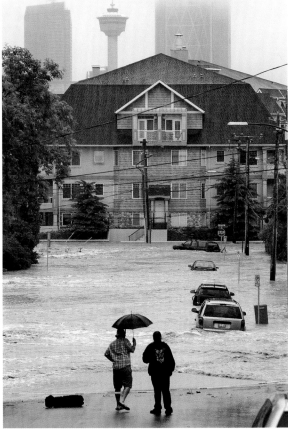

ABOVE LEFT The Calgary Fire Department rescued this family from their flooded Erlton apartment. (Gavin Young/ *Calgary Herald*)

FACING PAGE Parts of the East Village turned into a lake by June 21.

(Leah Hennel/*Calgary Herald*)

ABOVE RIGHT Under the shadow of the Calgary Tower, this street in Erlton was flooded by the Elbow River.

(Gavin Young/*Calgary Herald*)

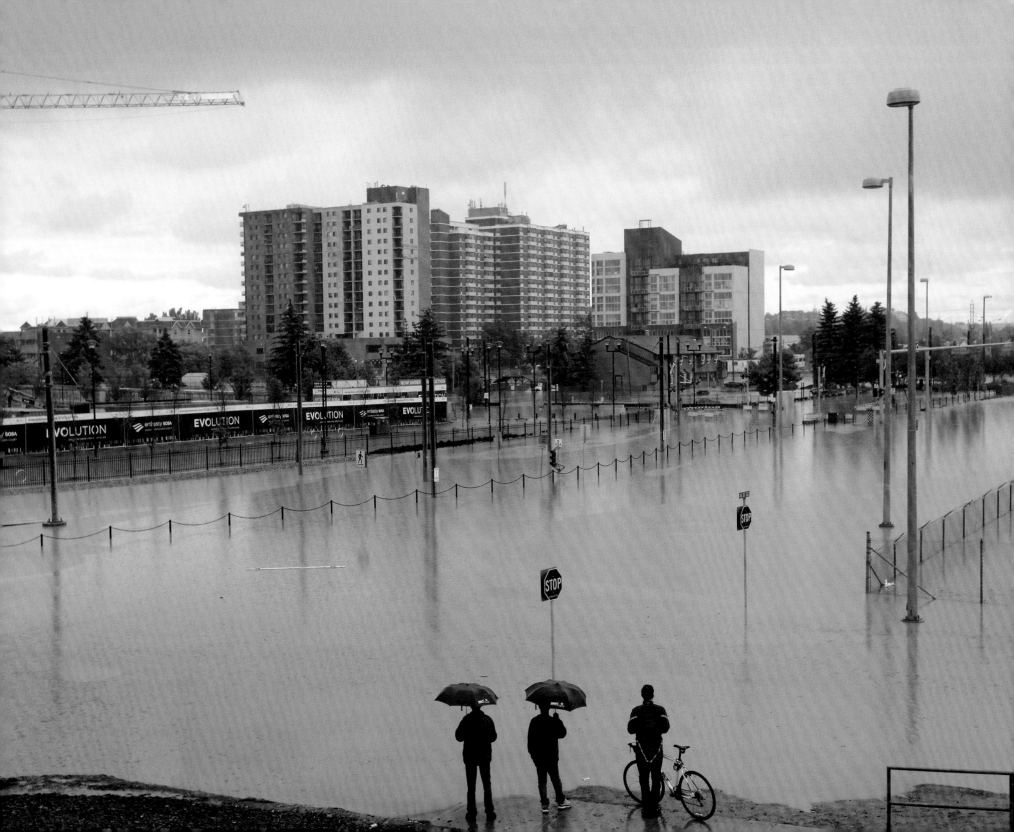

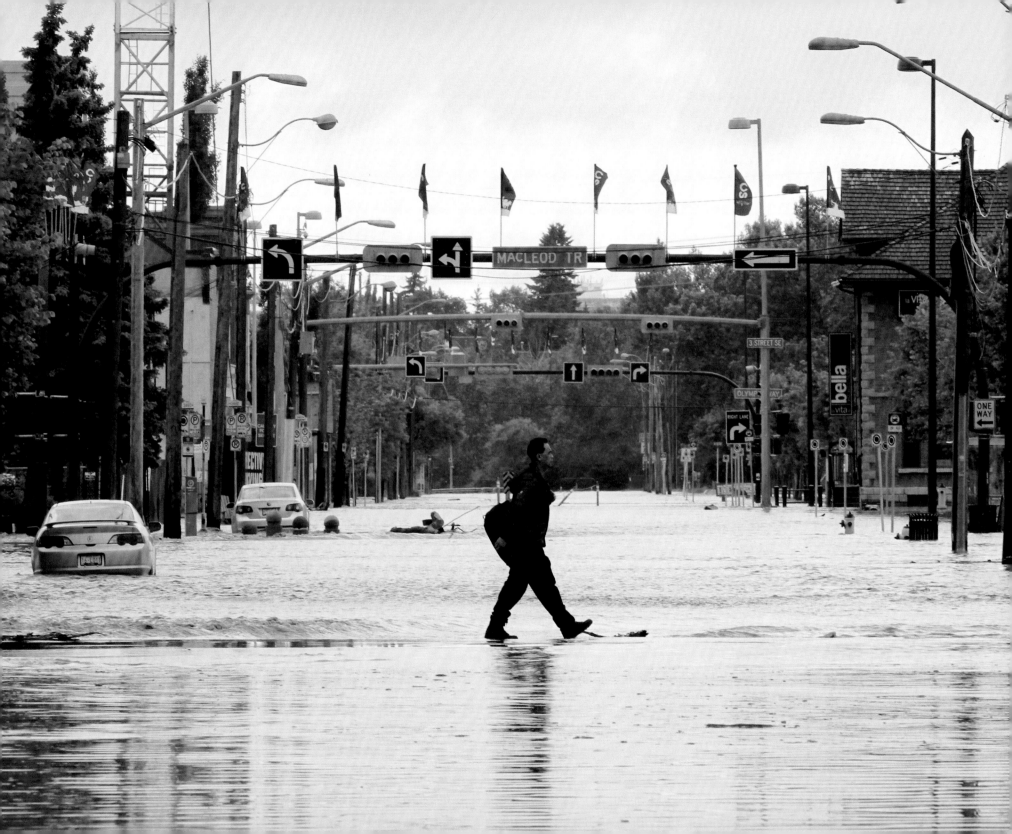

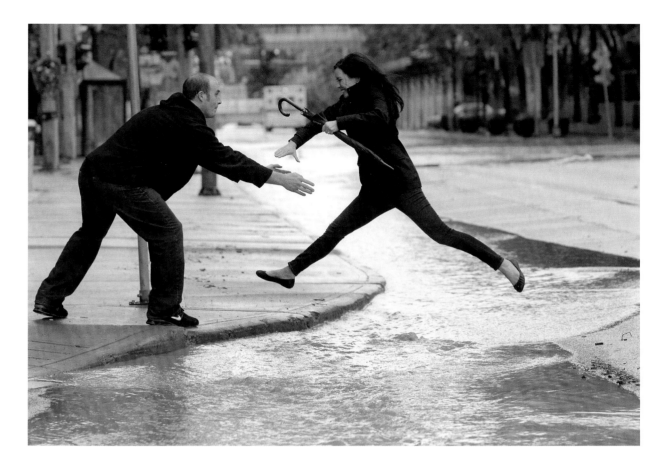

neighbourhood were under water. At a 5 AM media briefing in the municipal emergency operations centre, Nenshi said the city had only one goal: keep Calgarians safe.

The Calgary Zoo is partially located on St. George's Island, at the confluence of Calgary's two rivers. As the flooding grew worse, zoo workers risked their lives to keep the animals safe. Over ten hours on June 20, staff relocated more than 160 animals—from tigers and lions to snakes. Some animals, such as the zebras and pot-bellied pigs, were moved offsite. Others, such as the gorillas, were taken to higher areas in their own enclosures. After poring over topographical maps of the island, zoo personnel made the "very sad" decision to leave behind some animals they thought could survive in a few feet of water. Dr. Jake Veasey, the zoo's director of animal care, conservation and research, returned to the island early Friday morning to feed and assess the state of the remaining animals. The elephants were muddy but otherwise fine, as were the camels and gorillas.

But what Veasey found when he eventually swam into the African Savannah building was hair-raising: two shivering giraffes up

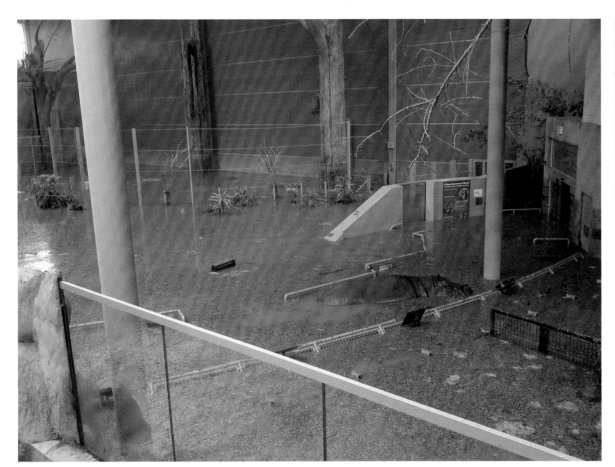

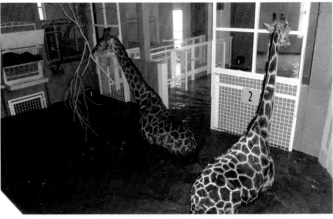

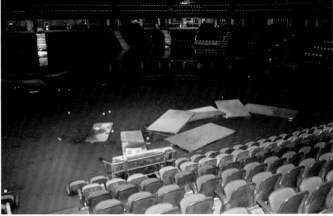

to their bellies in cold water and water levels so high that the two hippos were floating metres above where they were supposed to be. The potentially lethal hippos could have easily swam right out of the enclosure and into the Bow River. "We could have had hippos God knows where. They could have been twenty or thirty miles downstream," he later said. Veasey and other staff had to move concrete blocks in front of the building to prevent the hippos from escaping. A broken back window also had to be secured. At one point, the group parked a Bobcat out front and Veasey sat atop it, holding a rifle in case the hippos tried to escape. At the same time, the giraffes desperately needed to be moved out. Veasey donned a dry suit and, with a large-calibre rifle for protection, swam into the enclosure's back area with a few other staff. There was no power, the water was muddy brown and they had to make constant assessments of where the hippos were moving. Despite the best efforts of zoo staff, there were still some casualties. Two of the free-roaming peacocks

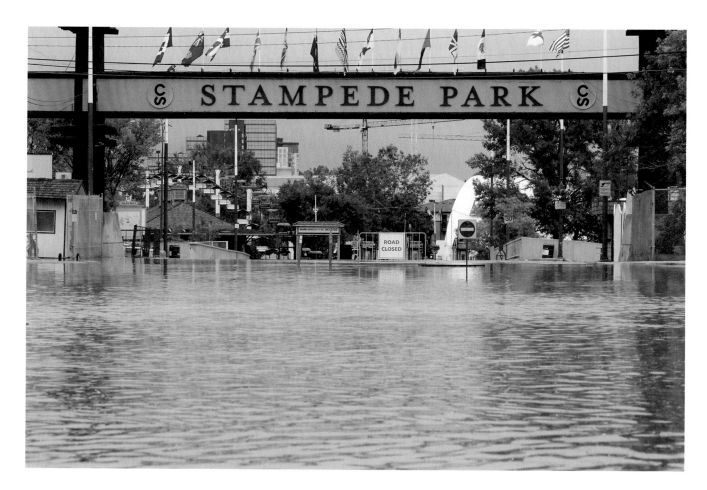

were found dead. Half of the piranhas didn't make it, and many of the tilapia kept in the hippo enclosure died. "We saved a huge proportion of this animal population that was destined to die in this flood—and dangerous animals, and in very dangerous situations," Veasey concluded.

On June 21, Calgarians woke up to stunningly high water levels along the Elbow and Bow Rivers, particularly in the communities of Elbow Park, Rideau-Roxboro and Stanley Park. Some homes were flooded up to two metres above the main levels. Streets in the fashionable Mission district turned into rivers. Macleod Trail was under water. Downtown commuters were asked to stay home—and most did—but getting around the city became an excruciating task, with at least twenty roads and seventeen bridges closed. The downtown became eerily quiet as office towers closed. Thirty parks were covered by flooding, including Prince's Island. In southeast Calgary, the views from Scotsman's Hill were jaw-dropping: Stampede Park

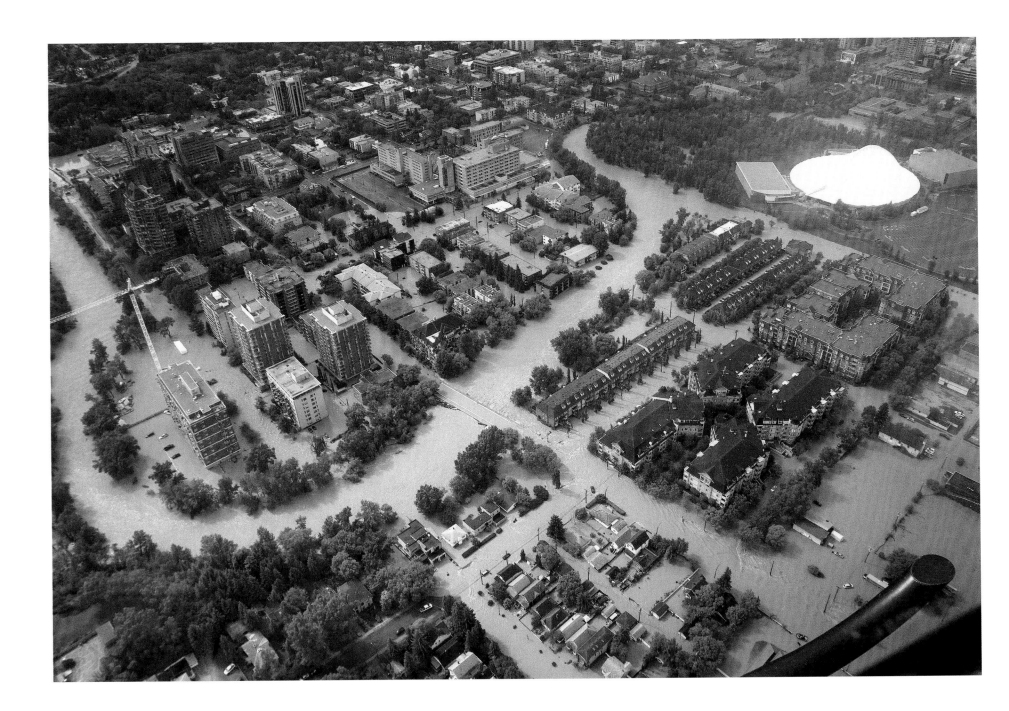

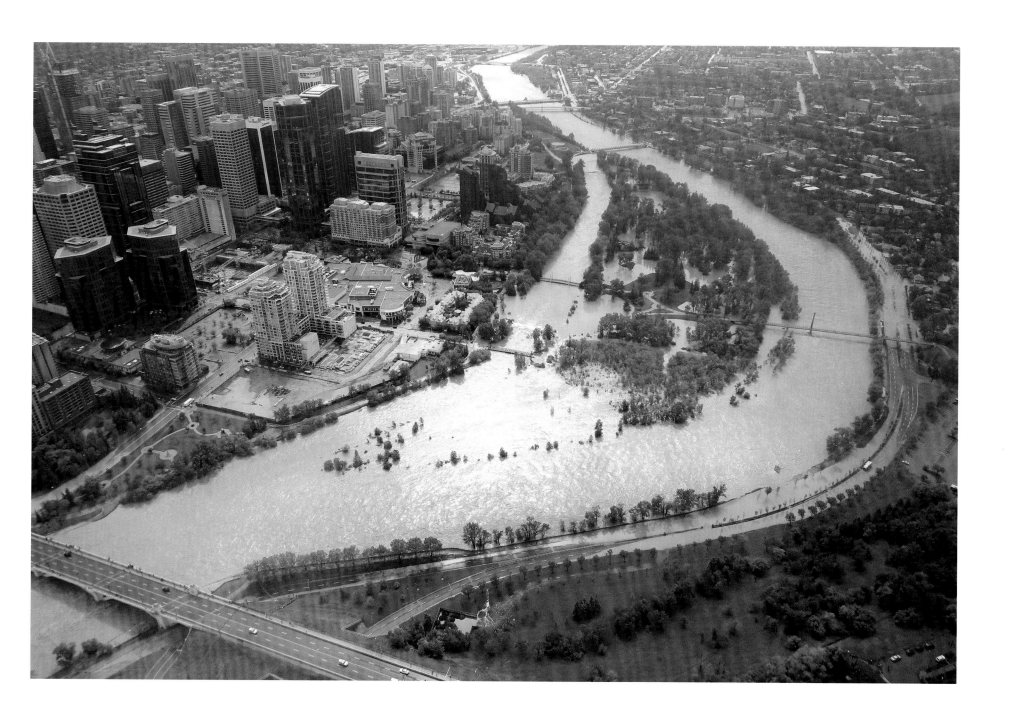

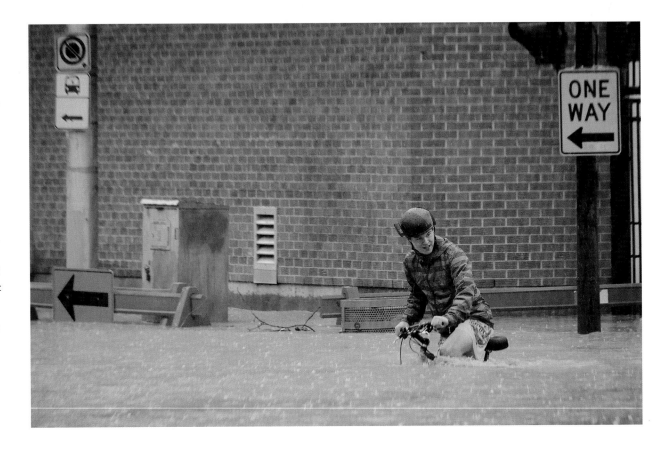

was covered by a lake of water just two weeks from the start of the Greatest Outdoor Show on Earth. Stampede officials put on a brave face, with chief executive Vern Kimball saying: "We're going to do our very best to put on a great Stampede." Equally shocking was the state of the Scotiabank Saddledome. Millions of litres of water seeped into the Calgary Flames' arena, eventually filling it up to the eighth row of seats. The event level—which includes the ice plant and kitchens, all of the dressing rooms and coaches' offices, not to mention the Jumbotron nerve centre—was a total loss.

Alberta premier Alison Redford surveyed the flooding in her hometown in the early morning of June 21 and could scarcely believe the unfolding disaster. Hours earlier, she had been in New York on government business but flew back to Calgary around midnight. After an emergency briefing, she toured the city—including her own riding of Calgary-Elbow—to see the damage. "We certainly, all as a community, need to pull together," she told reporters the next morning in Calgary. Following the news conference, the premier flew across southern Alberta to see the devastation. From the air, she saw water surrounding her late mother's home in High River. "I saw a little bit of roof and that was it. And you look at that and think

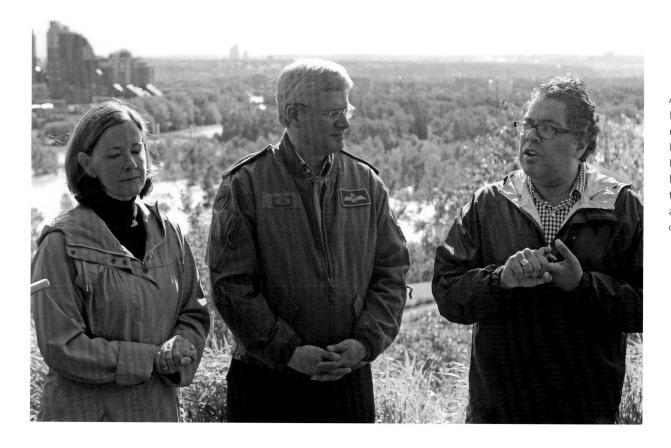

As the magnitude of the disaster hit home, Calgary's political leaders returned to the city. Premier Alison Redford and Prime Minister Stephen Harper listened while Mayor Naheed Nenshi answered media questions after the trio conducted an aerial tour of areas affected by the flooding on June 21. (Colleen De Neve/*Calgary Herald*)

about the time you spent there as a family, which is what everyone is doing," she later told the *Herald*. "It struck me that people's lives have been inalterably changed."

Later that day, three of the city's most high-profile politicians—Redford, Nenshi and Prime Minister Stephen Harper—stood on a hill overlooking the swamped community of Sunnyside and the roaring Bow River. The sun was shining, but the warm afternoon belied the grim work ahead. Following a helicopter tour, Harper, the MP for Calgary Southwest, told reporters he'd never seen anything like it. "Of course, this is a very resilient place, and when the worst passes, I

know everybody will rebuild and get back to life," the prime minister said. "But I know it's going to be a very difficult time."

Downstream from Calgary, the flood continued to wreak havoc. At least a thousand people were evacuated from the Siksika reserve east of Calgary, where homes were swamped by massive pools of water. Cabins from the Hidden Valley Resort were spotted floating downstream, smashing into bridges. Some displaced Siksika residents moved to high ground and camped out in tents. Others took shelter at the Deerfoot Sportsplex, which served as an evacuation centre. From the air, the nation's houses looked like islands

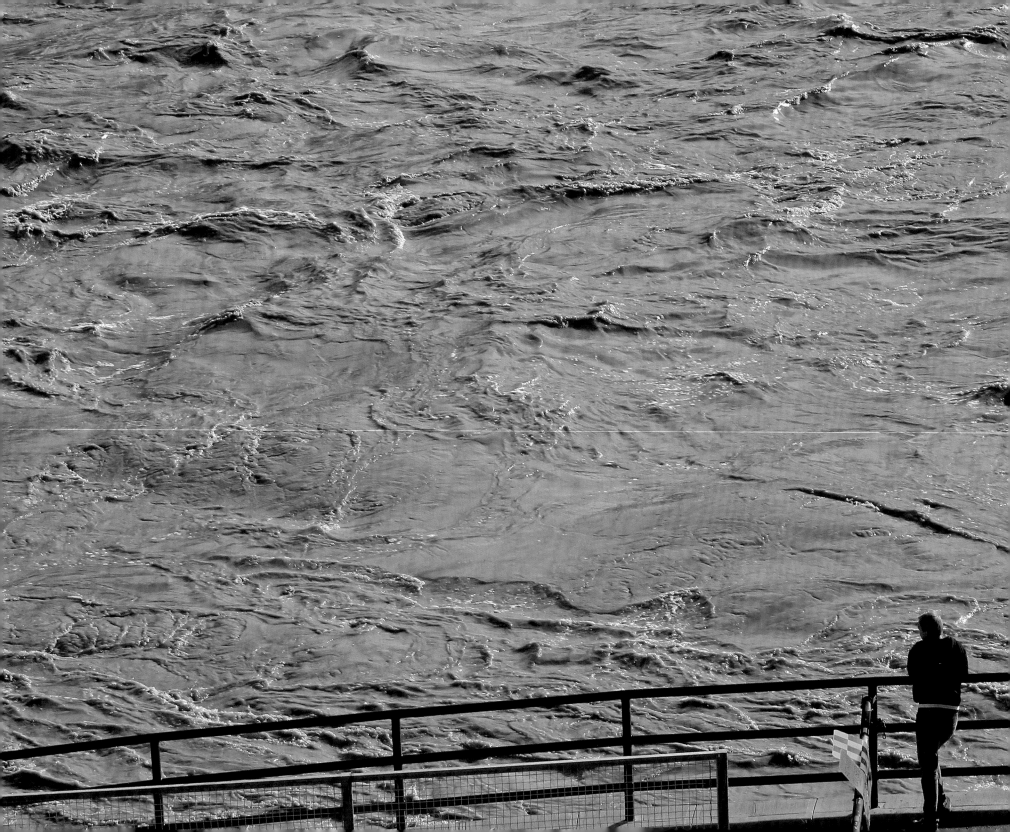

surrounded by a sea of water. "I've never seen anything like this in my life," said Siksika Nation chief Fred Rabbit Carrier. "It's devastating."

Tensions also began to rise in Medicine Hat, the southeast Alberta community that has battled fierce flooding many times. Officials feared they would have to close the Trans-Canada bridge that connects the north side of the city to the south—a move that would have cut the city in two—because of rising water in the South Saskatchewan River. Fortunately, with days to prepare and some good luck, the city was spared the catastrophic flooding that some had anticipated. Streets were under water, homes were flooded and several prominent civic buildings had water damage, but the prevailing emotion in the Gas City was one of relief.

By June 22, Calgarians finally heard some good news. Nenshi told reporters the city had turned a corner in its battle with the flood. Flow rates on the Elbow River began to decline. The first group of evacuees (people who had homes on high ground in Discovery Ridge in Calgary's western edge) was allowed to return home. There were also the first signs that despite all of the damage and uncertainty, Calgarians would get behind the Stampede. In what would soon become the rallying cry for the ten-day festival, people took to Twitter to pledge their support "come hell or high water." But the flood wasn't behind Calgary—or any other community—just yet. High water continued to cause serious problems to homes, roads, bridges, signals and pathways. The twisted CTrain track at the Erlton station looked like it was designed for a roller coaster. Power outages continued to affect a significant part of the core. Inglewood, one of the city's oldest communities, narrowly dodged a catastrophe when soldiers were called in to help erect barriers that protected homes from oblivion.

Gradually, through the weekend, evacuation orders in the city were lifted and the slow, enormous cleanup began. In High River, however, 80 per cent of homes were still without power and basic services. For hundreds of High River families, there was no indication when they would be allowed home. At a media briefing on June 23, the premier declared the flood the largest in Alberta's history—and pledged support for all that needed it. The past few days were "a devastating and emotionally overwhelming experience" for Albertans, Redford said. "We will live with this forever."

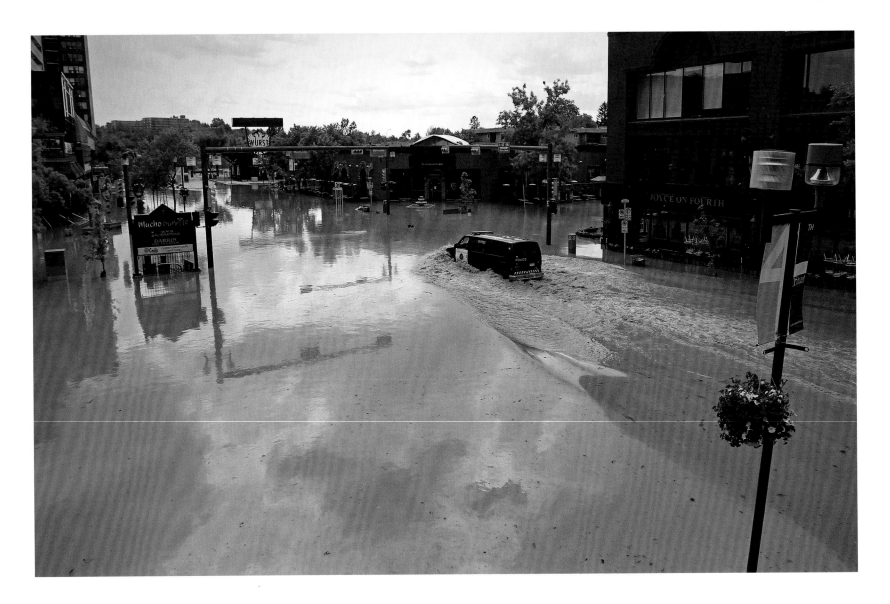

ABOVE A police van navigated through the flooded intersection of 4th Street and 24th Avenue sw in Mission on June 22. (Stuart Gradon/*Calgary Herald*)

FACING PAGE When the sun finally emerged over High River, a lake of water settled into the southeast corner of the near-vacant town on June 23.

(Lorraine Hjalte/*Calgary Herald*)

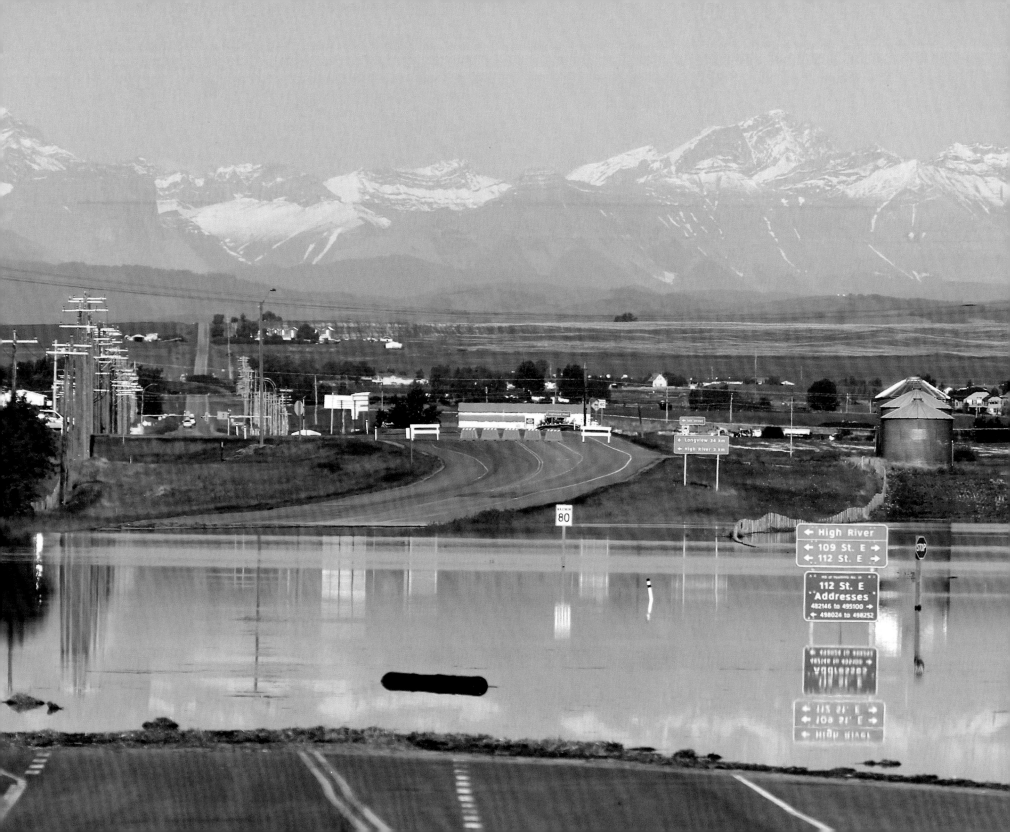

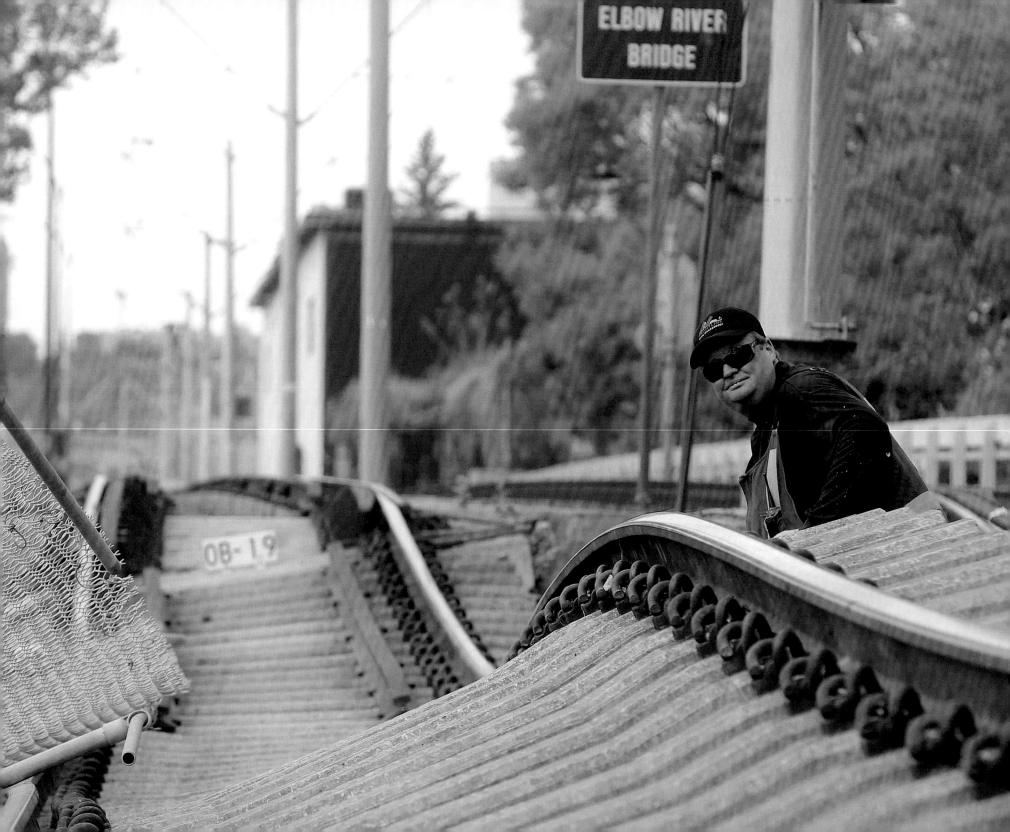

FACING PAGE Dean Hagen of the Calgary Transit Track and Way Department surveyed the damage to LRT tracks on June 23. Surging flood waters lifted the rails and twisted them off the track north of the Stampede-Erlton CTrain station. The adjacent northbound lanes of Macleod Trail were also destroyed.

(Ted Rhodes/*Calgary Herald*)

2 / DEVASTATION AND DESTRUCTION

WHEN THE FLOOD hit, people reacted instinctively, often with great courage. But when the water began to recede, adrenaline was replaced by shock and an overwhelming sense of loss. The damage seemed insurmountable: homes were ruined, cars were swept away, businesses were gutted and murky debris floated everywhere. Five lives were lost in the surge; many more were forever altered by the rivers' destruction.

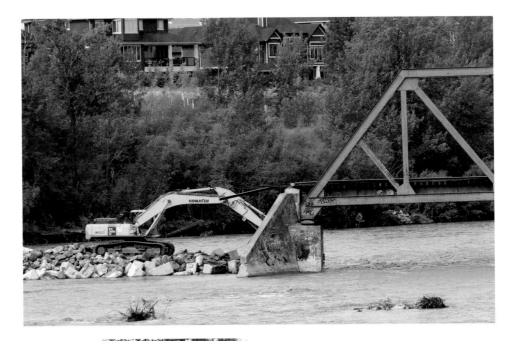

TOP RIGHT A trench had to be dug to relieve the rising Sheep River during the height of the flood in Black Diamond. The river changed direction and washed out the road that was connected to a bridge on Highway 22.

(Lorraine Hjalte/*Calgary Herald*)

BOTTOM RIGHT Crews worked on June 24 to restore the rail line running through Okotoks. The ground under the tracks was washed away by the Sheep River. (Lorraine Hjalte/*Calgary Herald*)

FACING PAGE Property restoration specialist Jason Hoerle inspected the interior of a condo filled with rocks and mud in the Silvertip Resort area of Canmore. Fourteen properties in the complex were extensively damaged when flood water and debris carved a new path down the mountainside directly into the complex.

(Craig Douce/*Rocky Mountain Outlook*)

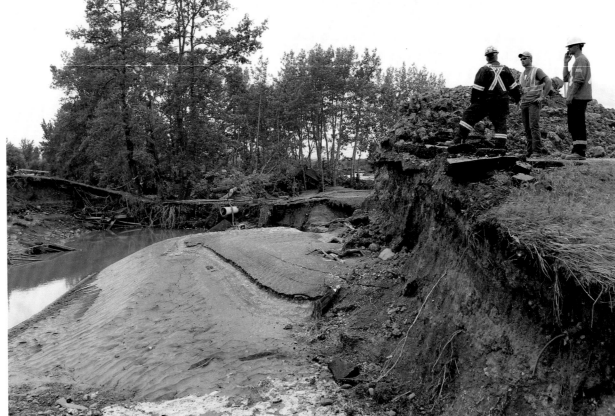

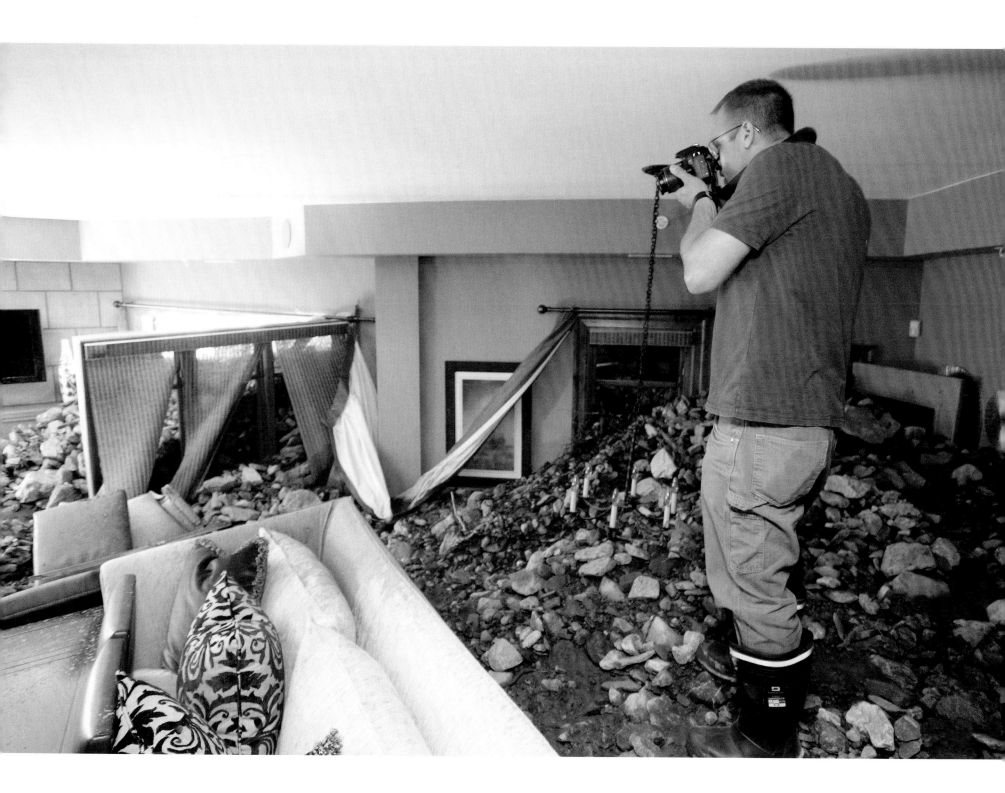

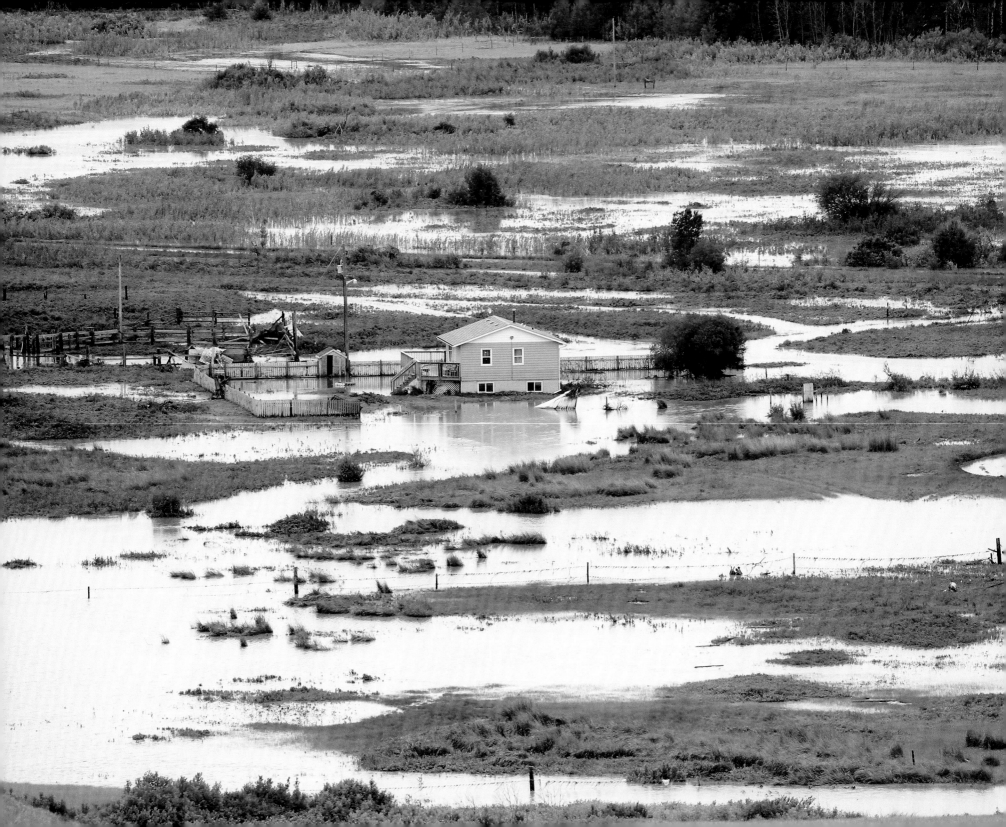

FACING PAGE After the flood waters receded, homes and properties on the Siksika reserve southeast of Calgary were left waterlogged and severely damaged. More than a thousand of the roughly thirty-five hundred residents were affected. (Colleen De Neve/*Calgary Herald*)

LEFT The flood water covering the Siksika reserve softened the ground, creating sinkholes. A grader in front of one home sunk several feet.

(Colleen De Neve/*Calgary Herald*)

ABOVE Ken Roome helped with the cleanup in Blairmore, in the Crowsnest Pass, after a surging Lyons Creek took out the CP Rail bridge.

(Leah Hennel/*Calgary Herald*)

FACING PAGE Homes in Bowness were left perching precariously close to the edge on June 25 after flood water eroded the banks of the Bow River.

(Leah Hennel/*Calgary Herald*)

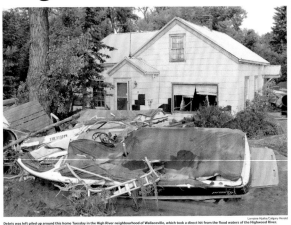

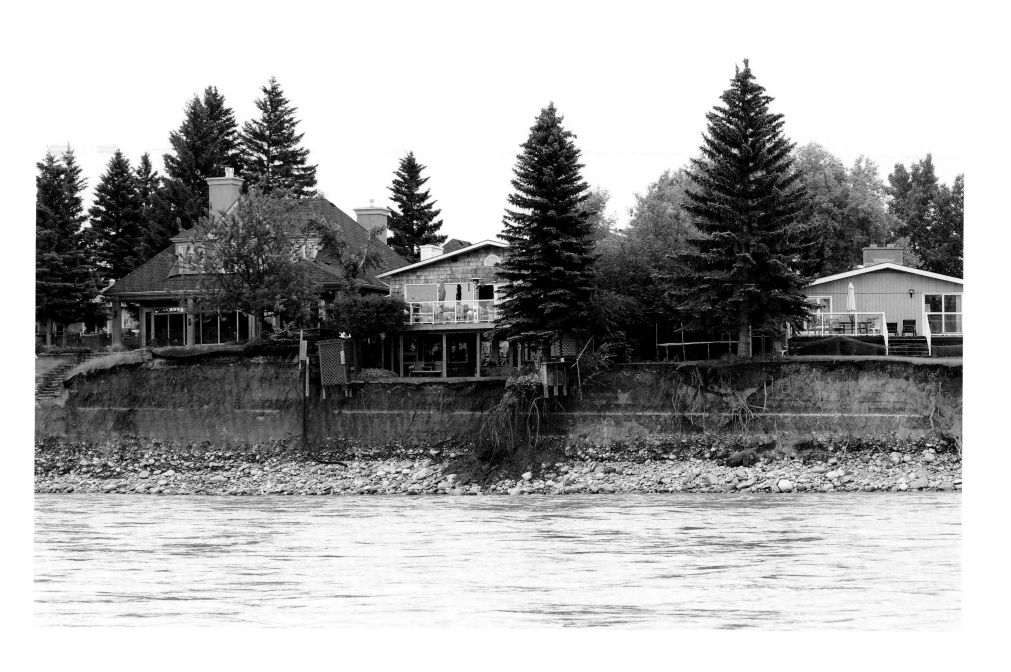

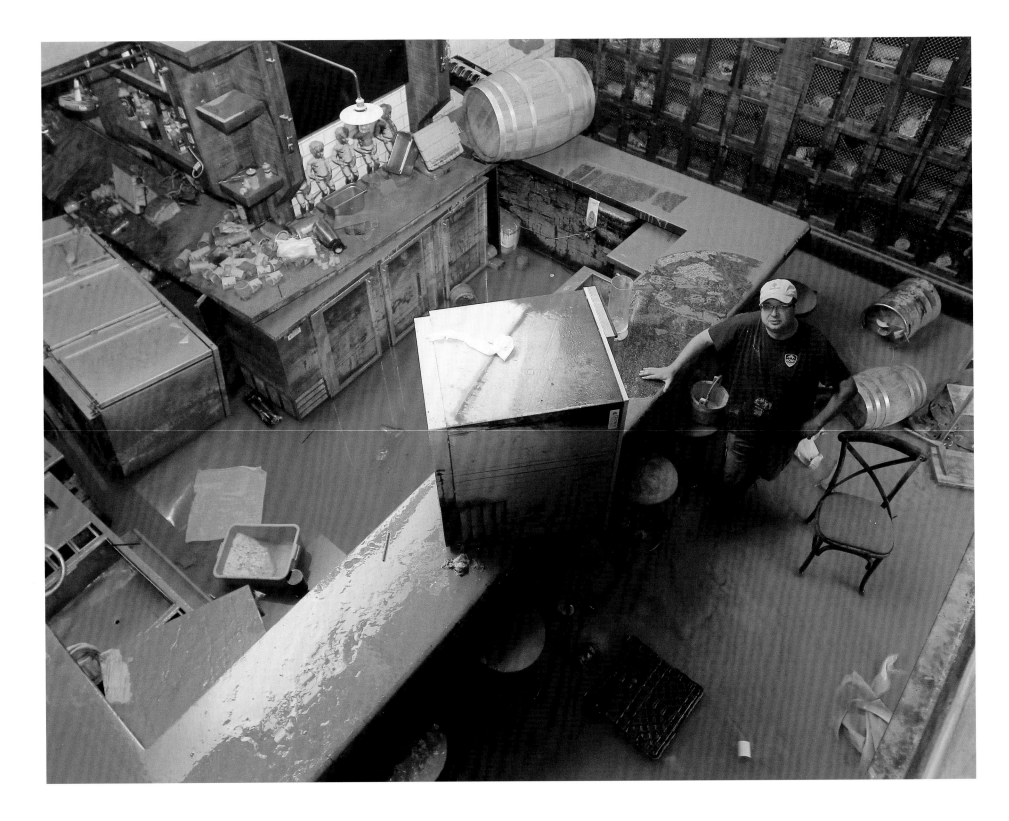

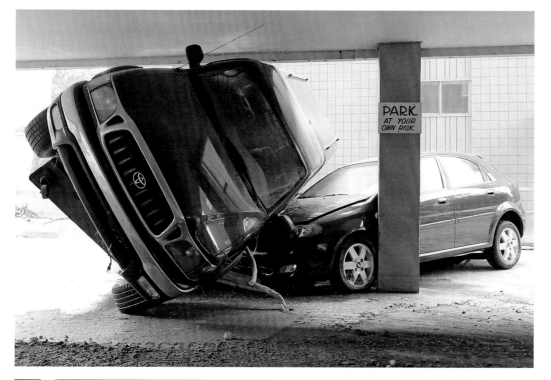

FACING PAGE Wurst owner Dominic Caracciolo looked over the damage in the flooded lower floor of his restaurant on 4th Street sw. (Stuart Gradon/*Calgary Herald*)

TOP LEFT The sign posted at this apartment parking garage in Mission, which was intended to warn against theft and vandalism, was unfortunately appropriate after flood water piled vehicles into each other. (Stuart Gradon/*Calgary Herald*)

BOTTOM LEFT Elbow Park was one of many Calgary neighbourhoods welcoming volunteers to help with the cleanup.

(Stuart Gradon/*Calgary Herald*)

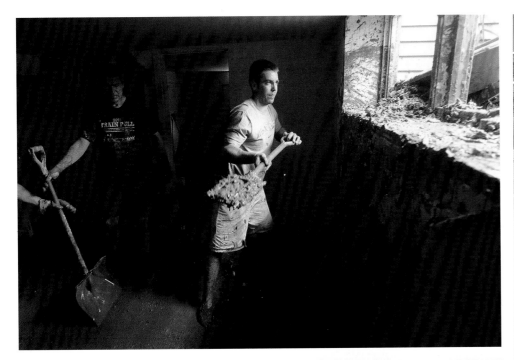

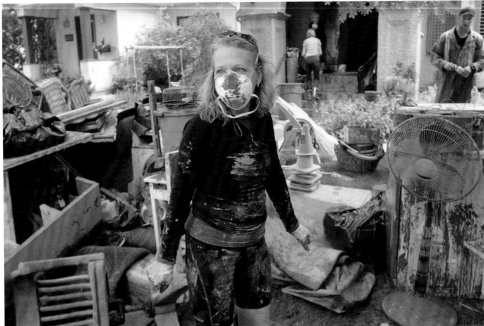

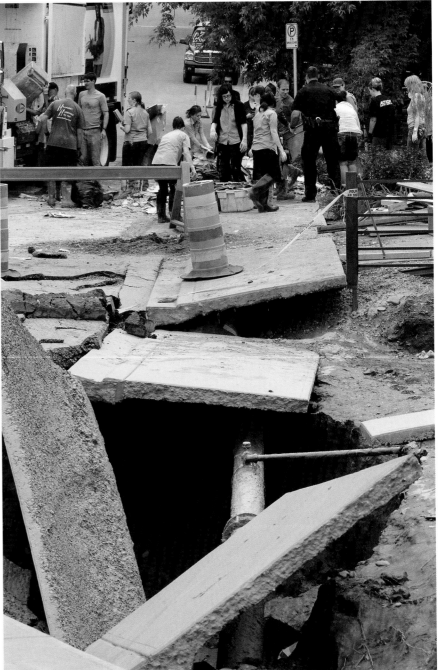

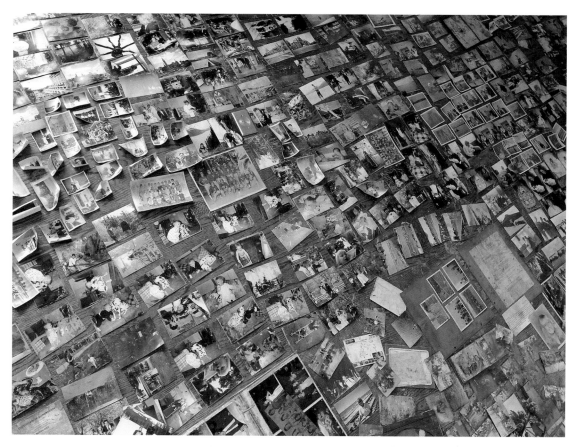

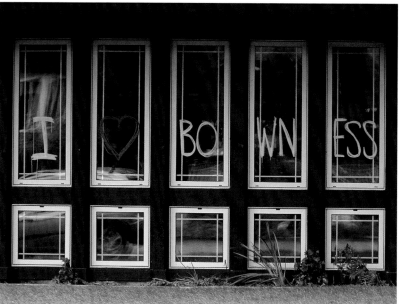

FACING PAGE BOTTOM LEFT Dayla Maisey was up to her face in mud while helping a friend salvage items from her flooded Rideau Park home.

(Ted Rhodes/*Calgary Herald*)

FACING PAGE TOP LEFT Alex Grieve shovelled the muck out of his parents' basement in Rideau Park on June 24.

(Ted Rhodes/*Calgary Herald*)

FACING PAGE RIGHT The power of the flood was evident in the torn-up road-way and chunks of missing pavement along Erlton Street near Stampede Park on June 25. (Gavin Young/*Calgary Herald*)

TOP LEFT Wet and dirty family photographs covered the floor of Katie McLean's home in Elbow Park. McLean's daughter Samantha and her friends spread out the pictures in a dry area in an attempt to save them.

(Stuart Gradon/*Calgary Herald*)

BOTTOM LEFT Residents and strangers who came together to help clean up Bowness left many homeowners grateful for the community support.

(Stuart Gradon/*Calgary Herald*)

TOP RIGHT Vehicles were washed up outside the flooded Burnco plant in southeast Calgary. (Tijana Martin/*Calgary Herald*)

BOTTOM RIGHT Members of the Canadian military—deployed in several parts of southern Alberta to help with rescue and recovery missions—are seen here at High River, where work was occurring to build a temporary berm and access into the town. (Lorraine Hjalte/*Calgary Herald*)

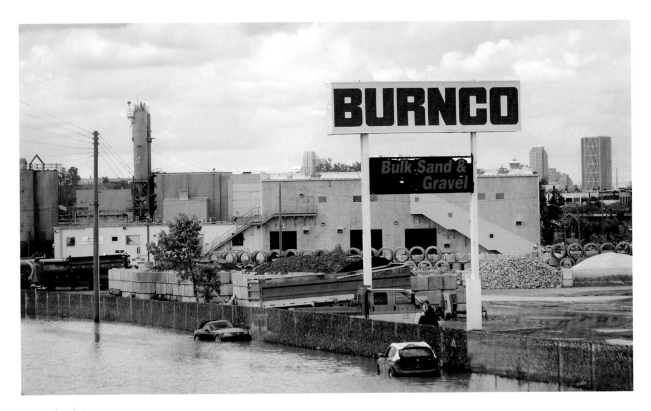

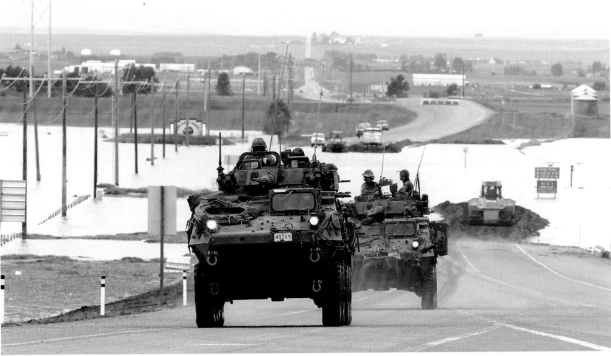

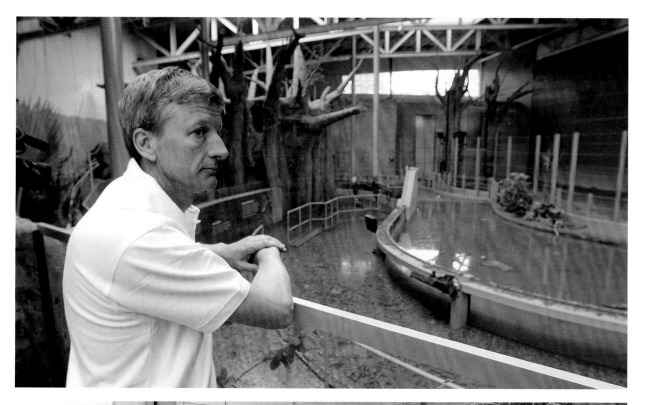

TOP LEFT Calgary Zoo president and CEO Clement Lanthier surveyed the damage in the African Savannah building on June 25. When the building flooded, the hippos were able to swim up and out of their enclosure. Many animals had to be evacuated and housed elsewhere. (Colleen De Neve/*Calgary Herald*)

BOTTOM LEFT Calgary Zoo keeper Kati Hrynewich waited and watched anxiously to see if the rock hyrax was still in its enclosure on June 25. Zoo staff began the process of cleaning up after being swamped by both the Bow and Elbow Rivers. (Colleen De Neve/*Calgary Herald*)

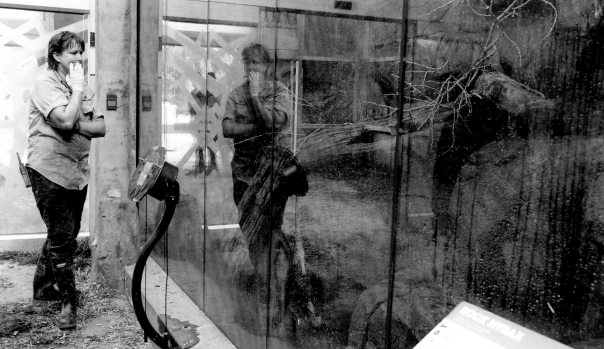

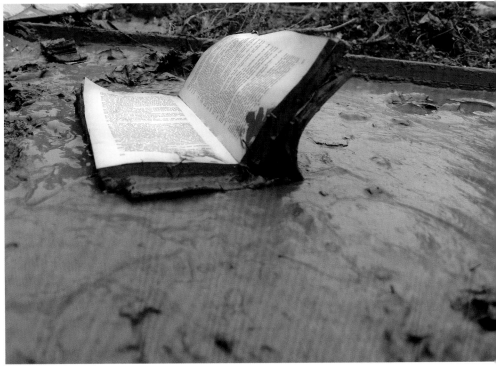

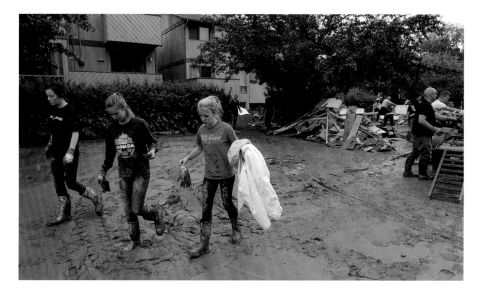

FACING PAGE LEFT A footprint was left in the dried mud outside the elephant enclosure at the Calgary Zoo. (Colleen De Neve/*Calgary Herald*)

FACING PAGE RIGHT A mud-covered book on the ground in Bowness was a simple reminder of all that was lost when the flood swept through people's homes. (Leah Hennel/*Calgary Herald*)

TOP LEFT Fourteen-year-olds Jessie Leggatt, Cassidy Goeson and Maddie Leggatt donned boots and gloves to help clean up in Bowness. (Leah Hennel/*Calgary Herald*)

BOTTOM LEFT Sheldon Kennedy— a former NHL player, now an advocate for sexual abuse victims—surveyed the ruined property and destruction at his Erlton home in Calgary. Property he owned outside of the city was also dramatically affected by the overflowing Highwood River. (Ted Rhodes/*Calgary Herald*)

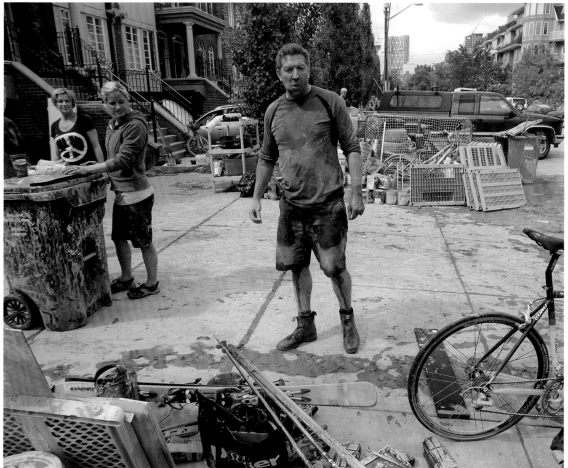

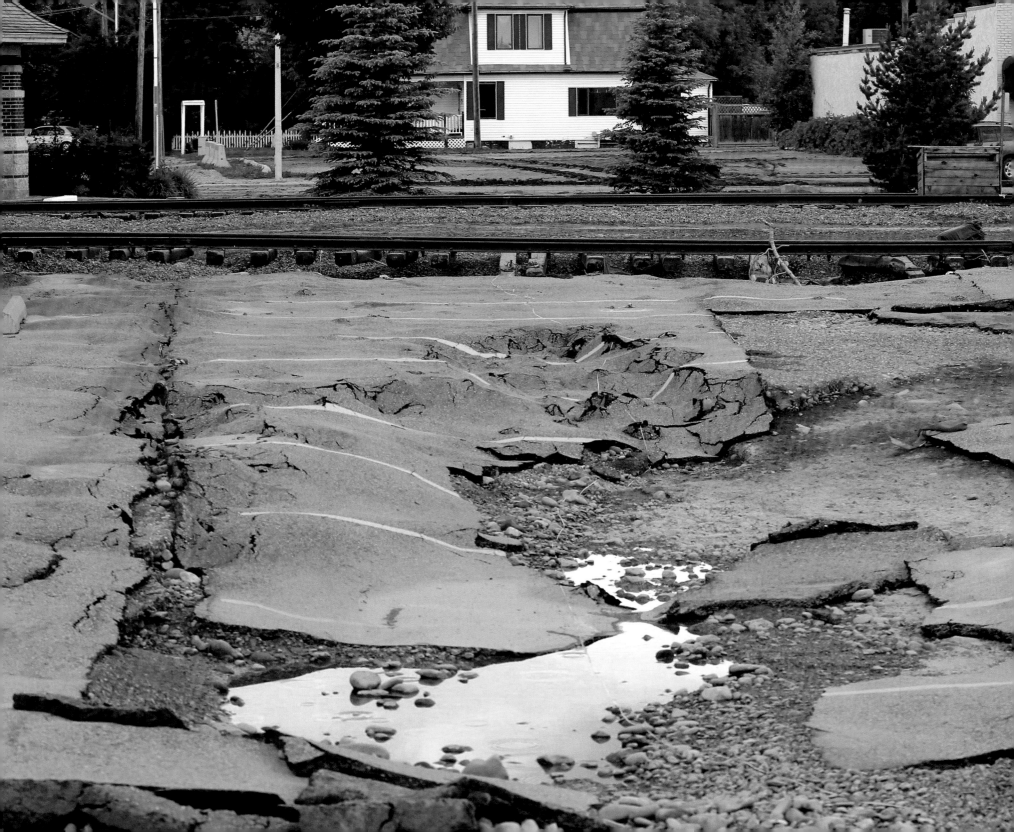

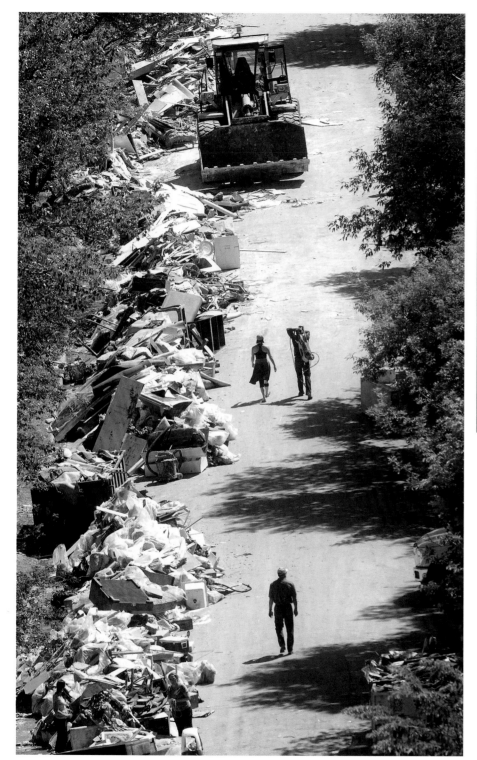

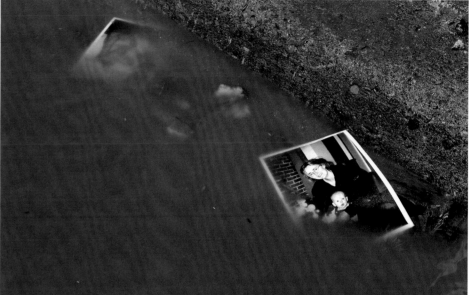

FACING PAGE The flooding Highwood River crumbled and demolished many roads in High River, creating a difficult and dangerous situation for those left in the town. (Lorraine Hjalte/*Calgary Herald*)

LEFT Mounds of debris were stacked up on 4 A Street NW in Sunnyside as people gutted their homes and discarded their ruined belongings.

(Ted Rhodes/*Calgary Herald*)

ABOVE Family photographs were left floating down a road in Bowness on June 26. Many treasured keepsakes stored in basements were destroyed.

(Leah Hennel/*Calgary Herald*)

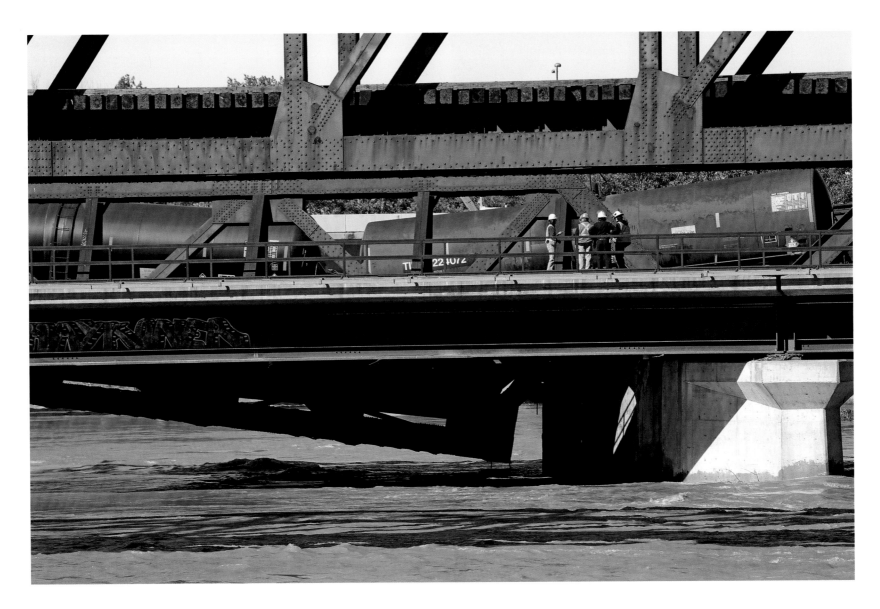

ABOVE Crews worked to stabilize tanker cars on the collapsed CP Rail bridge over the Bow River in Ogden. The flood's damage to the bridge's footings went undetected until this train passed on June 27. Five of the six cars that derailed were carrying a flammable petroleum product and they teetered over the river until they were stabilized with cables.

(Gavin Young/*Calgary Herald*)

FACING PAGE Norm Ederle's home in Bowness was damaged by the flood and many of his ruined possessions were added to the pile of debris outside.

(Leah Hennel/*Calgary Herald*)

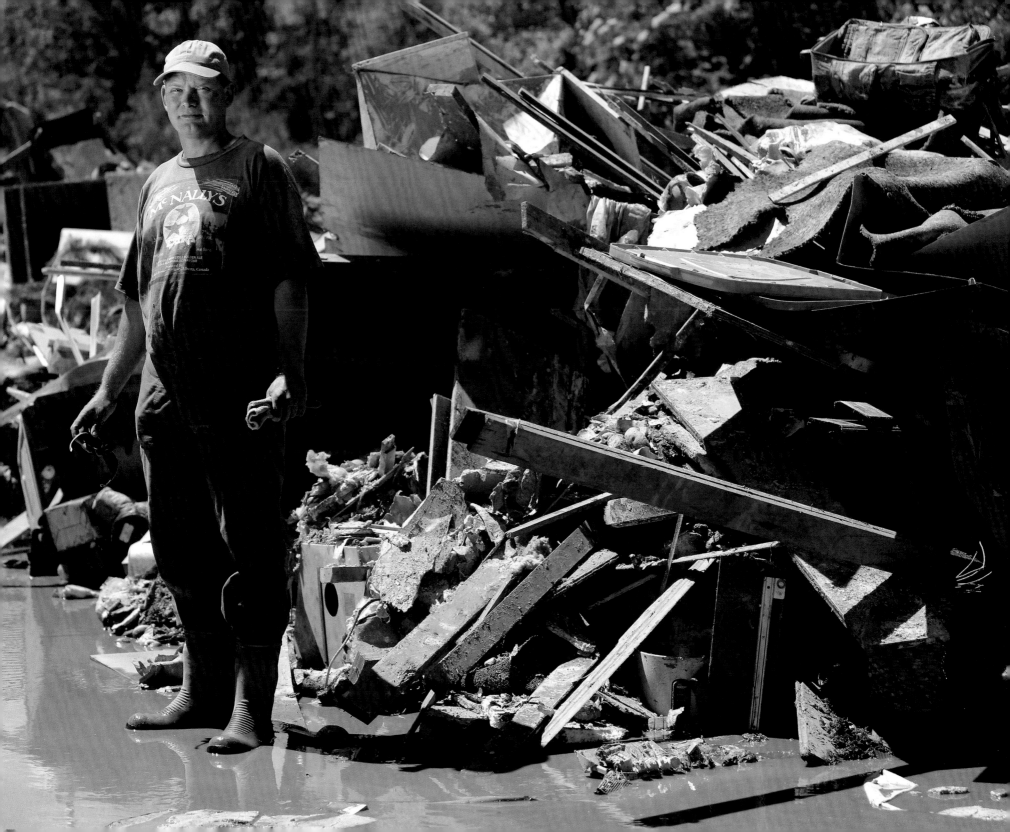

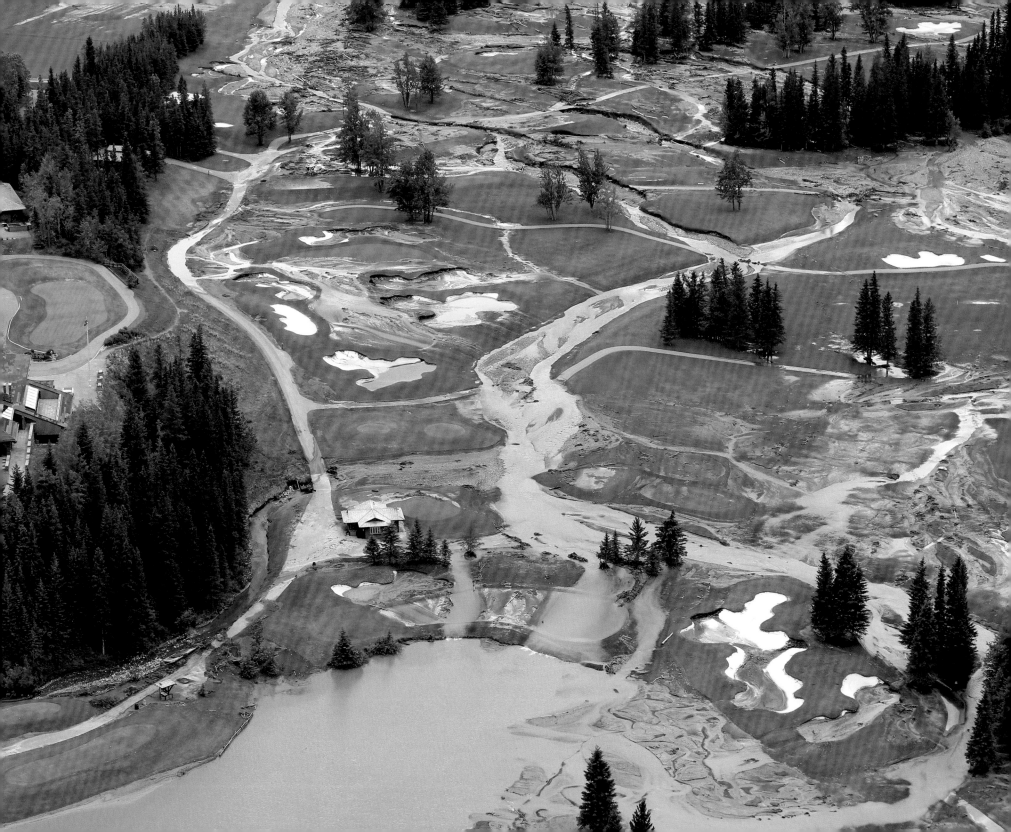

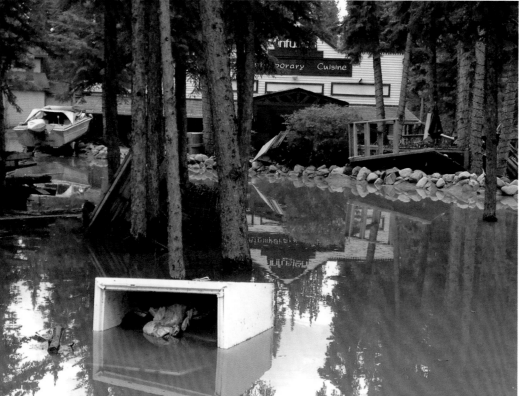

FACING PAGE The Kanaskis Country Golf Course was heavily damaged when the Evan Thomas Creek burst its banks and carved deep channels across the thirty-six-hole course. It will remain closed for the season, and the Alberta government is still deciding whether to restore the property or close it for good.

(Gavin Young/*Calgary Herald*)

TOP LEFT Bragg Creek was hard hit when the Elbow River surged over the bank and swept through town. Debris from businesses in the two strip malls was piled up in the parking lot as people shovelled out muck.

(Michele Jarvie/*Calgary Herald*)

BOTTOM LEFT An open freezer full of food and a motorboat were some of the items left in front of a devastated Infusion restaurant in Bragg Creek. The forested patio area was demolished and everything inside was a writeoff.

(Michele Jarvie/*Calgary Herald*)

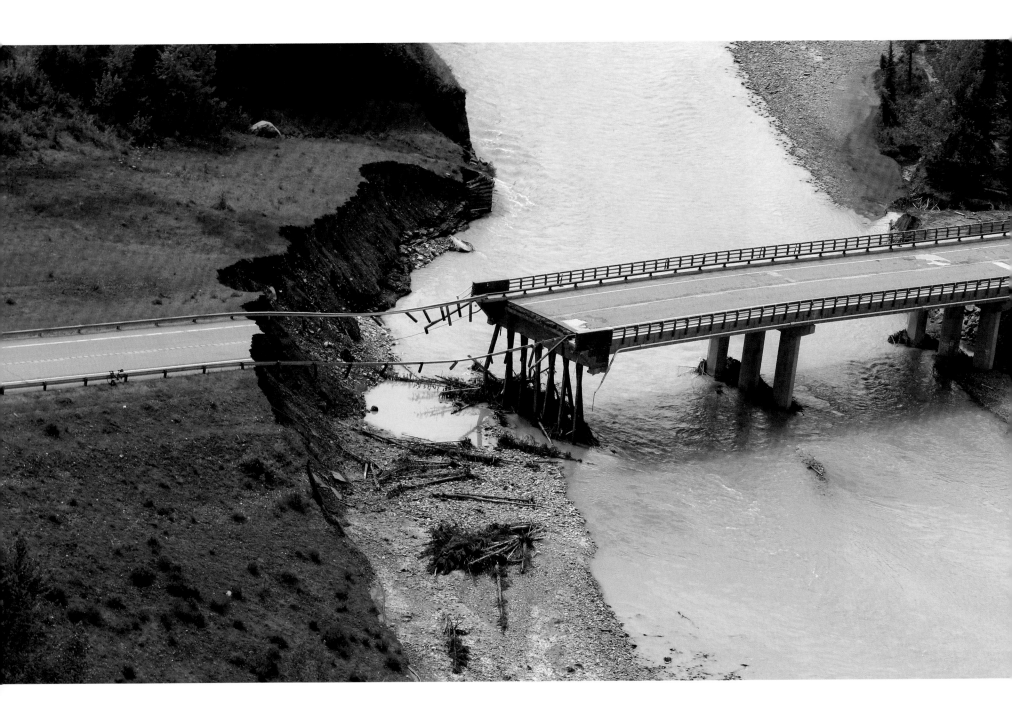

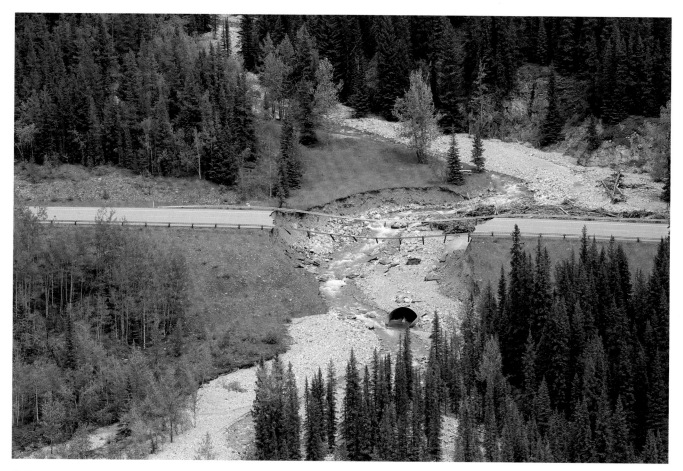

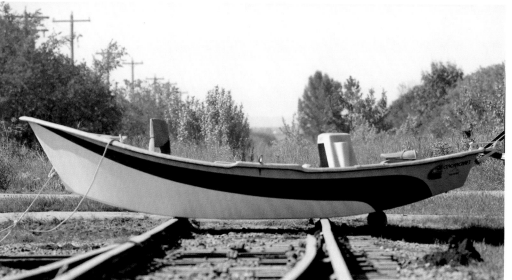

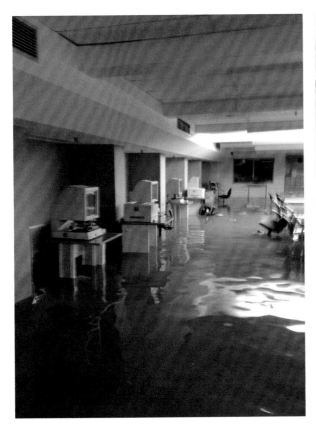

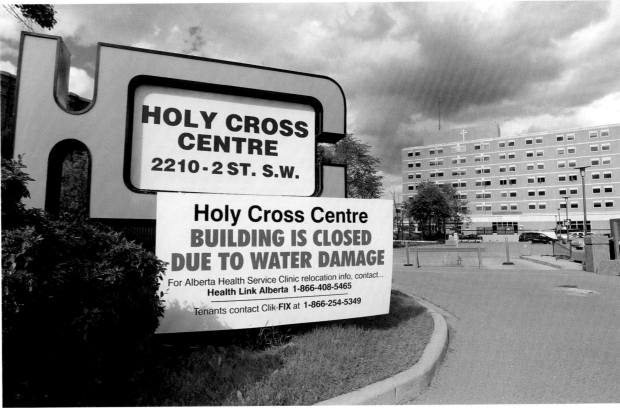

ABOVE LEFT The Calgary Public Library's central branch suffered extensive damage to its basement, resulting in the ruin of thousands of books, computers, microfiche equipment and local maps dating back to the 1800s.

(Courtesy of the Calgary Public Library)

ABOVE RIGHT Not only did the floods cause chaos and force most schools to close early for the summer break; they also caused problems within the health system. Flooding at the Holy Cross Centre forced the relocation of cancer clinics, assessments and follow-up meetings, and thousands of other medical appointments were cancelled when flooding closed dozens of family physicians' offices. (Stuart Gradon/Calgary Herald)

FACING PAGE High River Abbeyfield House resident John Jackson surveys the retirement home's ruined dining room. When the flood struck, residents had to flee to the second floor and await rescue. (Gavin Young/Calgary Herald)

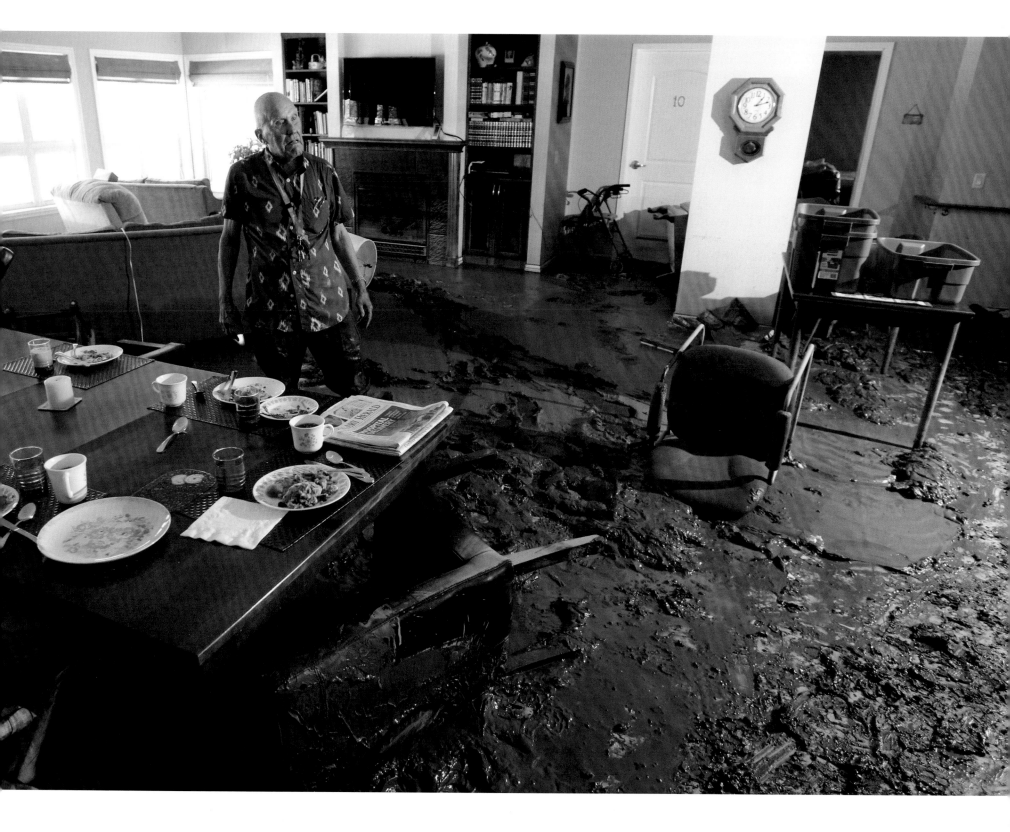

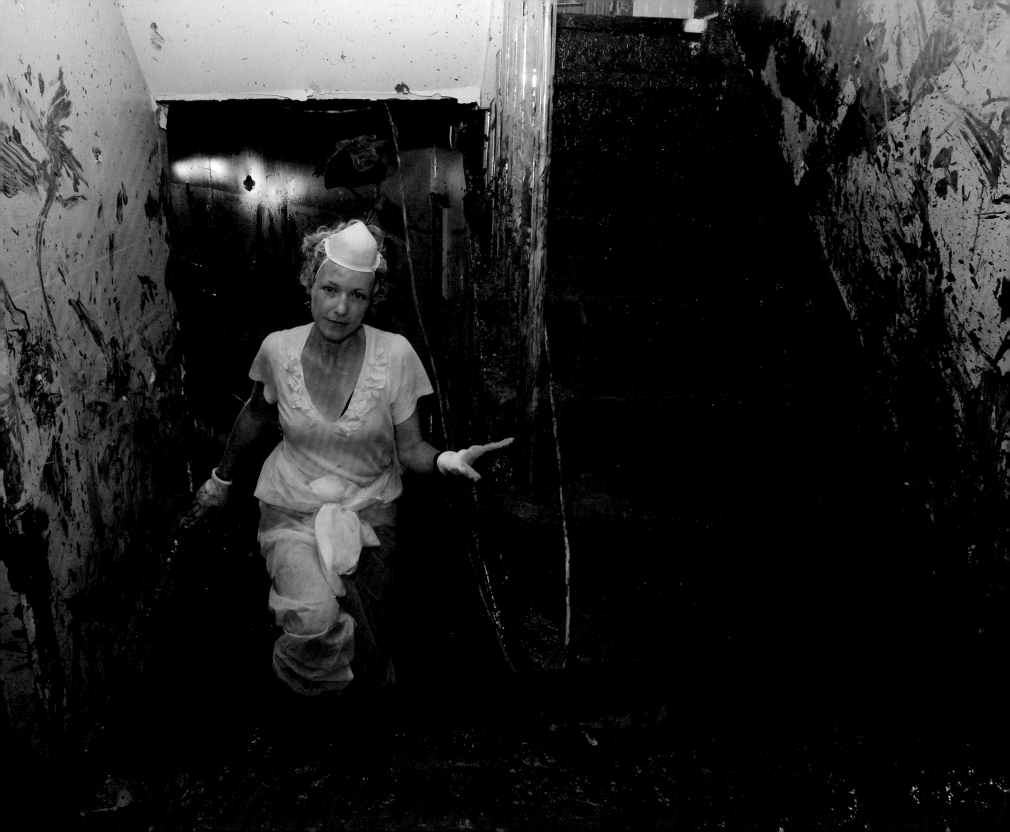

STAMPS EXTRA: YOUR GUIDE TO THE CFL SEASON See Sports, Pages C1-C7

CALGARY HERALD

OUTSTANDING CALGARY AND INTERNATIONAL CORPORATE PHILANTHROPIST 2012-13

BREAKING NEWS AT CALGARYHERALD.COM PROUDLY CALGARY SINCE 1883 THURSDAY, JUNE 27, 2013

THE FLOOD OF 2013

High River residents rage against mayor

Evacuees moved to Lethbridge as they push for return to homes **PAGE A5**

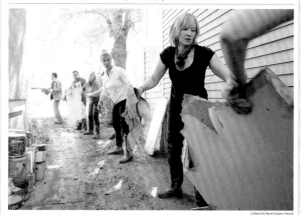

Laureen Harper, right, wife of Prime Minister Stephen Harper, helps clean out the basement of a Rideau home on Wednesday as part of flood-relief efforts. Colleen De Neve/Calgary Herald

Laureen Harper put in hours of manual labour Wednesday, helping clean out homes and deliver food in flood-hit areas

LICIA CORBELLA COLUMN, PAGE A3

17 PAGES OF COVERAGE

REDFORD CALLS FUNDING FAIR
REGIONS GETTING EQUAL TREATMENT, PREMIER SAYS
Page A3

TRANS-CANADA REOPENS
HIGHWAY 1 NEAR CANMORE BACK UP IN TIME FOR LONG WEEKEND
Page A2

Follow us online: Get the latest updates on the flood situation
CALGARYHERALD.COM

MOUNTAINS OF GARBAGE CREATE 'NIGHTMARE' IN ELBOW PARK **PAGE A4**

STRANDED WILDLIFE SAVED FROM DISASTER **PAGE A8**
Gavin Young/Calgary Herald

CAMBODIAN ORPHANS MAKE HUMBLING GIFT TO ALBERTA **PAGE A4**

Ted Rhodes/Calgary Herald

FACING PAGE Lindsay Snodgrass walked up from her muck-filled basement in her High River west end home; during the flood, the water broke through the windows, filling the basement and main floor with water and mud.

(Lorraine Hjalte/*Calgary Herald*)

3 / THE CLEANUP

W ITH TENS OF thousands of southern Alberta homes damaged by the flood, it quickly became apparent that cleaning up wouldn't be easy. Municipalities implemented disaster plans that mobilized man and machine. A wide range of businesses donated equipment, resources and staff to help however they could. And people from all walks of life picked up shovels and began digging out, one scoop of mud at a time.

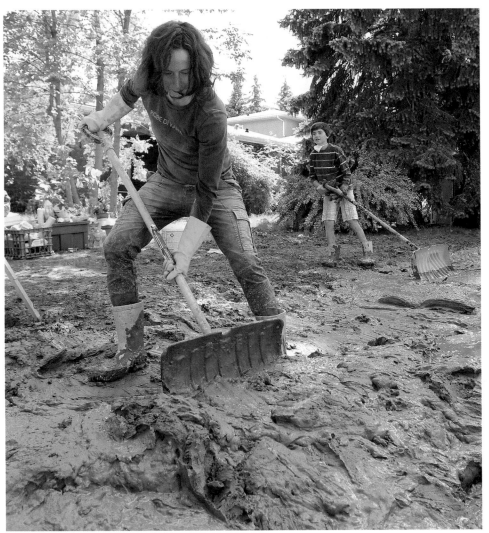

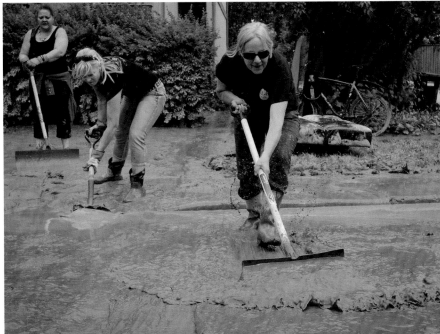

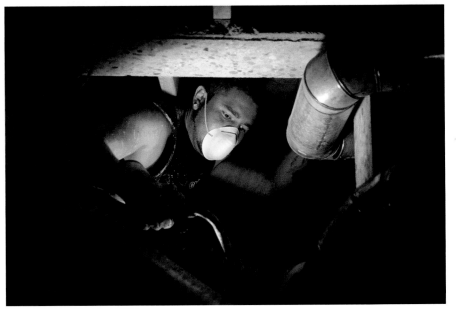

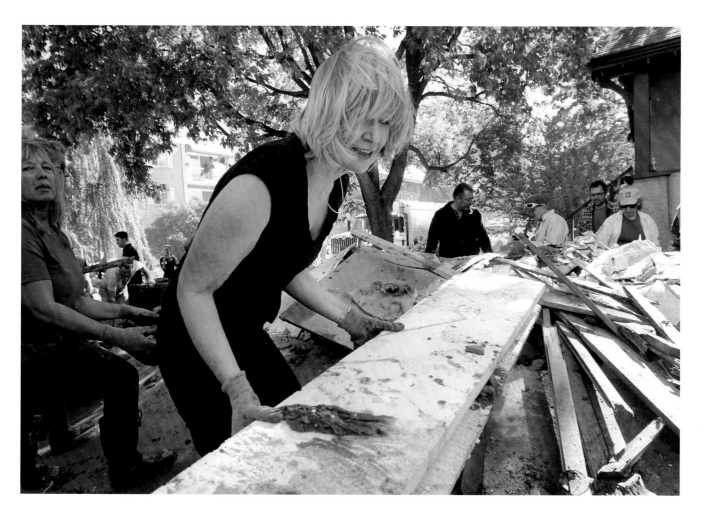

FACING PAGE FAR LEFT Lesley Farrar and her son Lucas Krayacich cleared a friend's sidewalk in the flood-affected community of Elboya in Calgary.
(Stuart Gradon/*Calgary Herald*)

FACING PAGE TOP RIGHT Carre Regnier, Kim Caputo and Judi Vandenbrink (from left to right) worked on moving mud from the Bowness neighbourhood.
(Tijana Martin/*Calgary Herald*)

FACING PAGE BOTTOM RIGHT In addition to the cleanup of mud and muck, electrical, plumbing and structural elements needed inspection in thousands of homes. Franklin Naves worked on a house in the Elbow Park area of Calgary on June 29. (Tijana Martin/*Calgary Herald*)

LEFT One of the early arrivals from Ottawa who came to help clean up was the prime minister's wife, Laureen Harper, who was seen lifting debris in the Calgary community of Mission on June 26. (Colleen De Neve/*Calgary Herald*)

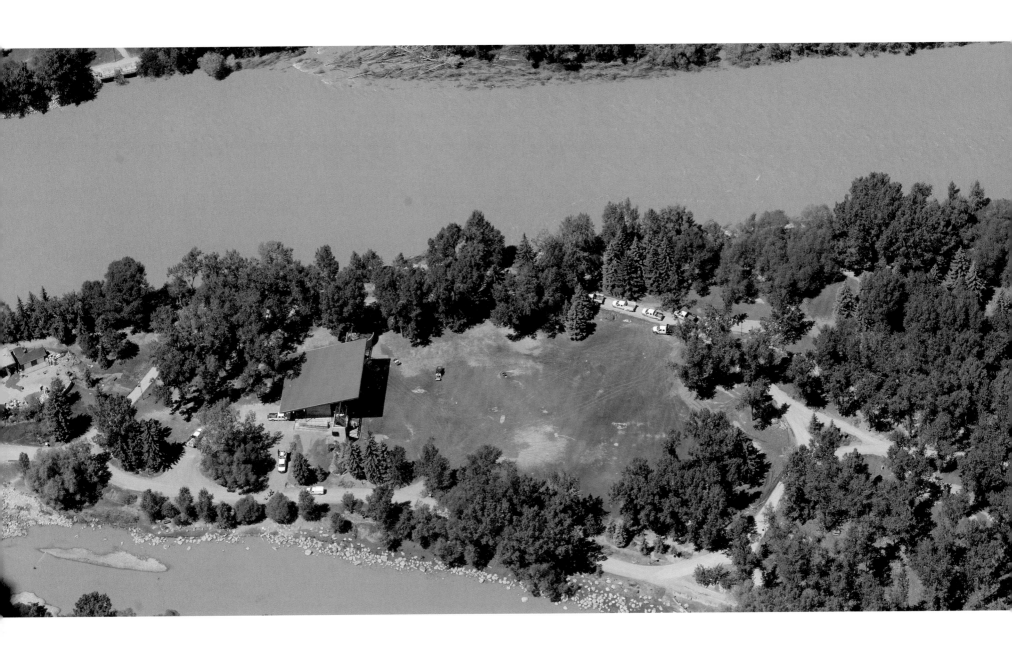

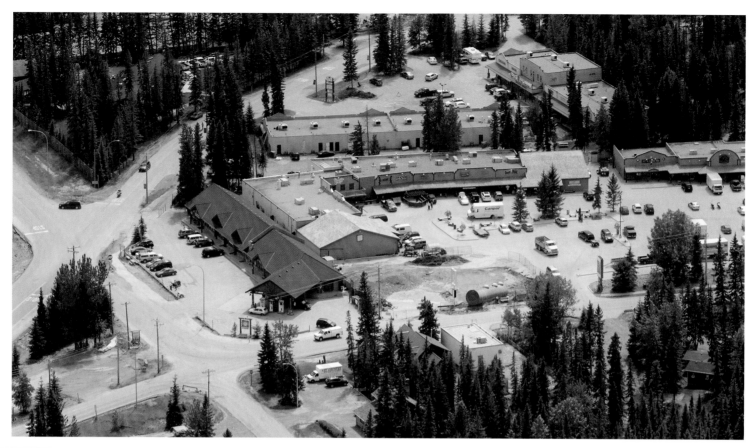

FACING PAGE One week after the flood, the Bow River was still a murky brown colour as it flowed past Prince's Island Park, where crews began to desperately repair the island before the mid-July Calgary Folk Music Festival.

(Ted Rhodes/*Calgary Herald*)

LEFT Calgary's old and new city hall buildings suffered substantial damage; it would be weeks before parts of the complex were functioning again.

(Colleen De Neve/*Calgary Herald*)

ABOVE Work was also beginning on repairs to the central business district of Bragg Creek, which had been submerged during the floods.

(Ted Rhodes/*Calgary Herald*)

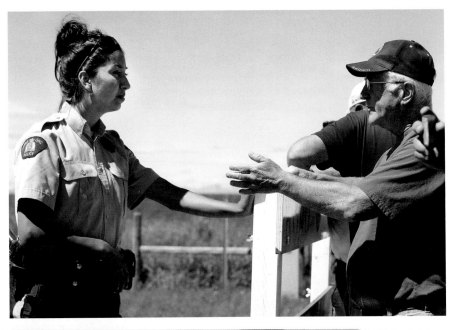

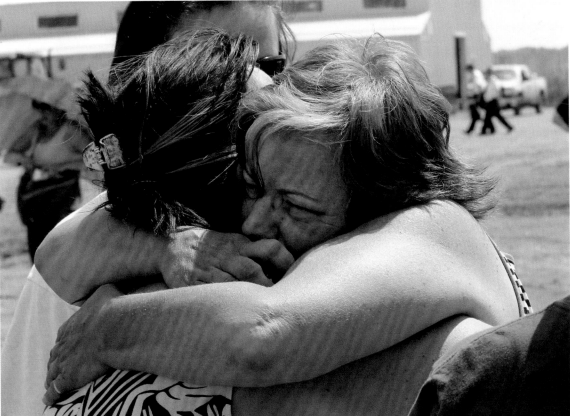

STAMPEDERS' OPENER Sports, Pages C1, C3 Plus Horsepower section | CEO PAY IN CALGARY See Calgary Business, Page E1

CALGARY HERALD

OUTSTANDING CALGARY AND INTERNATIONAL CORPORATE PHILANTHROPIST 2012-13

BREAKING NEWS AT CALGARYHERALD.COM PROUDLY CALGARY SINCE 1883 FRIDAY, JUNE 28, 2013

THE FLOOD OF 2013

Crews work at the scene of a bridge failure southeast of downtown on Thursday, where rail cars carrying petroleum products were at risk of falling into the Bow River. Larry MacDougal/The Canadian Press

DAY OF NERVES

Southern Alberta on edge as a damaged bridge threatened to dump rail cars into the Bow River and displaced High River residents confronted RCMP

See stories, Pages A2, A3 and A5

GOOD NEWS A TALL ORDER
GIRAFFES RECOVERING AT THE ZOO AS PETS GIVEN SHELTER
Pages A7, A20

PHOTOGRAPHERS CAPTURE A CITY FACING THE POWER OF NATURE
INSIDE
swerve

K-COUNTRY DESTRUCTION
AERIAL PICTURES OF RECREATION AREA TELL 'HEARTBREAKING' TALE
Page A4

Evacuee Greg Kvisle talks to Staff Sgt. Kevin Morton as High River residents seek answers on when they can return to their homes. Lorraine Hjalte/Calgary Herald

Follow us online: Get the latest updates on the flood situation. Also, watch for live chats offering breaking information
CALGARYHERALD.COM

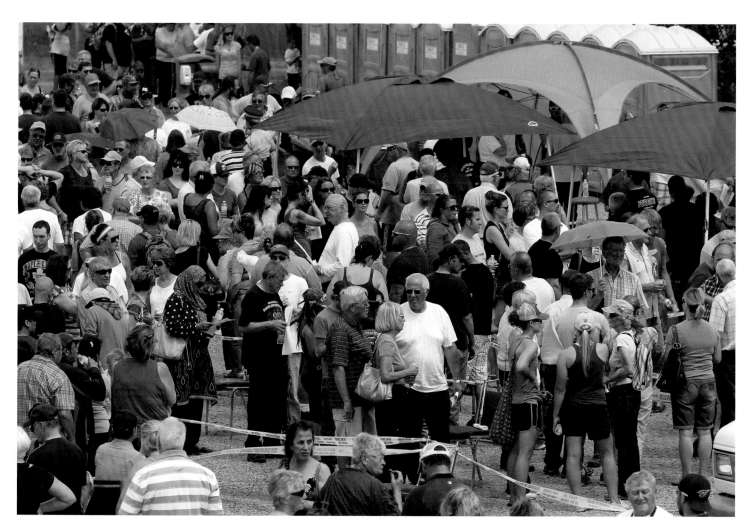

FACING PAGE TOP In High River it took a while for the cleanup to begin, as the entire town was under a mandatory evacuation order for a longer period. Many evacuees grew increasingly concerned about the state of their homes, as they waited for more than a week to see the damage for themselves. RCMP members were posted at town entrances to prevent people from driving into High River before it was safe to do so. Eventually, a staged re-entry occurred. (Lorraine Hjalte/*Calgary Herald*)

FACING PAGE BOTTOM Evacuees were anxious to get back to their homes to assess damage, including Chris Carney, who got a hug from her daughter Brooklyn Carney as they lined up to register to return to their High River homes.

(Lorraine Hjalte/*Calgary Herald*)

LEFT High River evacuees endured long waits to get information about their homes before being allowed to return.

(Lorraine Hjalte/*Calgary Herald*)

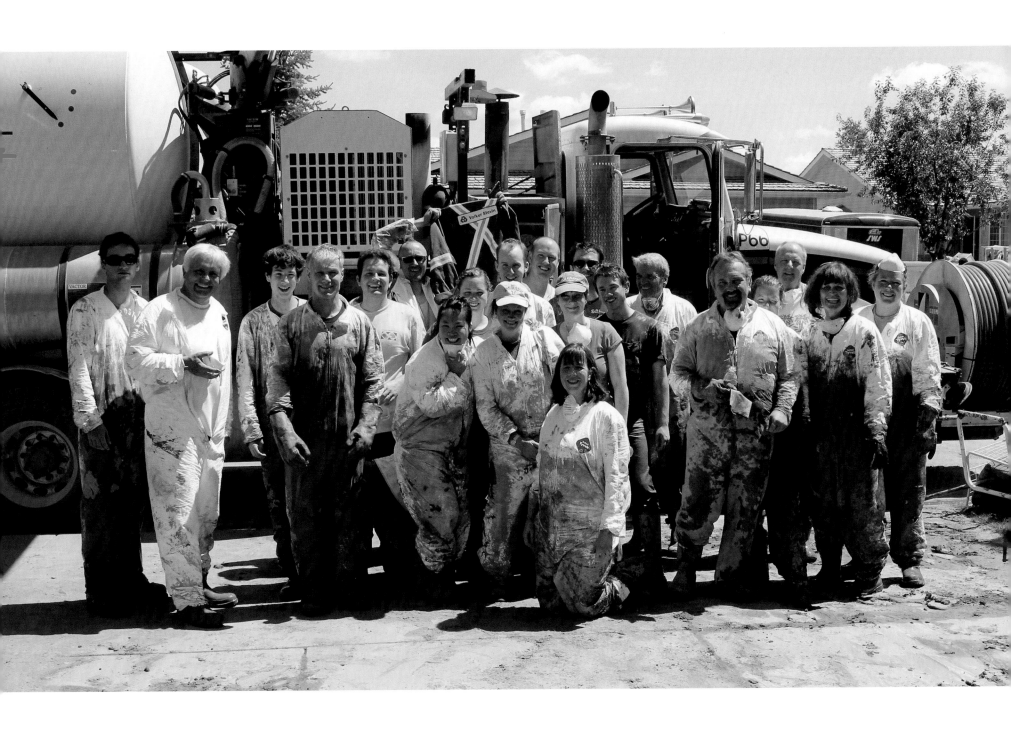

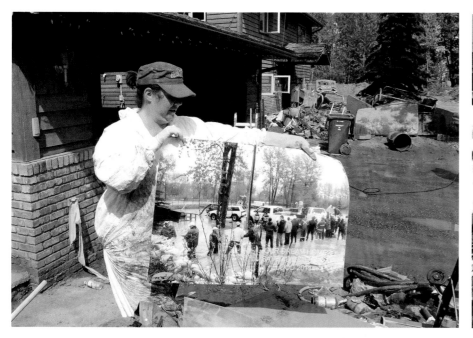

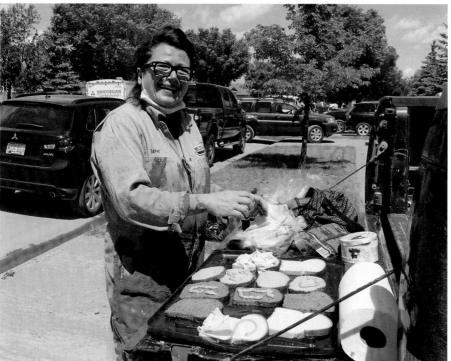

FACING PAGE The cleanup was a dirty job, as demonstrated by how quickly some of these volunteers' coveralls became covered in mud and sludge in High River. (Lorraine Hjalte/*Calgary Herald*)

BOTTOM LEFT Maureen Marshall made sandwiches for the volunteers at her grandparents' home in High River.

(Lorraine Hjalte/*Calgary Herald*)

TOP LEFT In a sad twist, Juliana Halifax held up a picture she rescued from flood waters that shows her home being saved by volunteers and sandbags during a 2011 flood. The 2013 flood, unfortunately, caused substantial damage in the Wallaceville area of High River where she lived.

(Lorraine Hjalte/*Calgary Herald*)

TOP RIGHT Simon Bordeniuk added items to an ever-growing pile of garbage in an area of High River where homes were declared code red, meaning the structural integrity of the houses could be compromised. (Lorraine Hjalte/*Calgary Herald*)

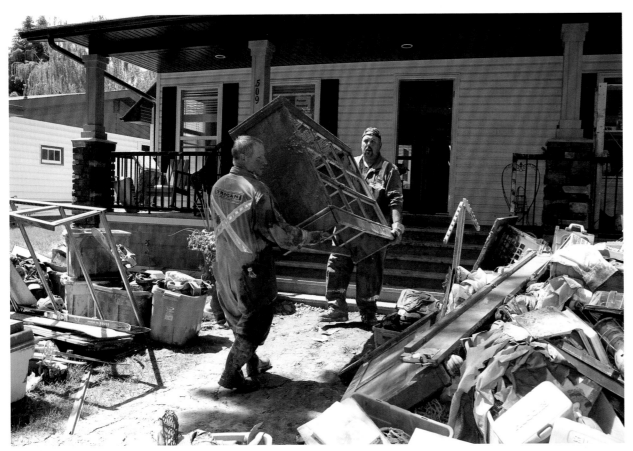

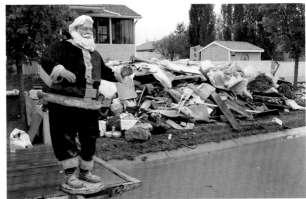

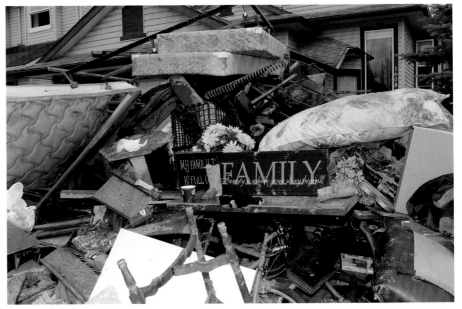

ABOVE LEFT Trican volunteers from Red Deer—Otto Geratschek and Jason Heffer—pitched in by removing soiled furniture and debris in High River. (Lorraine Hjalte/*Calgary Herald*)

ABOVE RIGHT Someone showed his sense of humour by setting up this muddy Santa to greet people in Sunshine Meadows. (Lorraine Hjalte/*Calgary Herald*)

RIGHT Many people lost every imaginable piece of household goods, as seen by the debris on this front lawn in Sunshine Meadows. (Lorraine Hjalte/*Calgary Herald*)

FACING PAGE Tate Snodgrass dumped a container of mud into a sea of mud, while helping family members in High River. (Lorraine Hjalte/*Calgary Herald*)

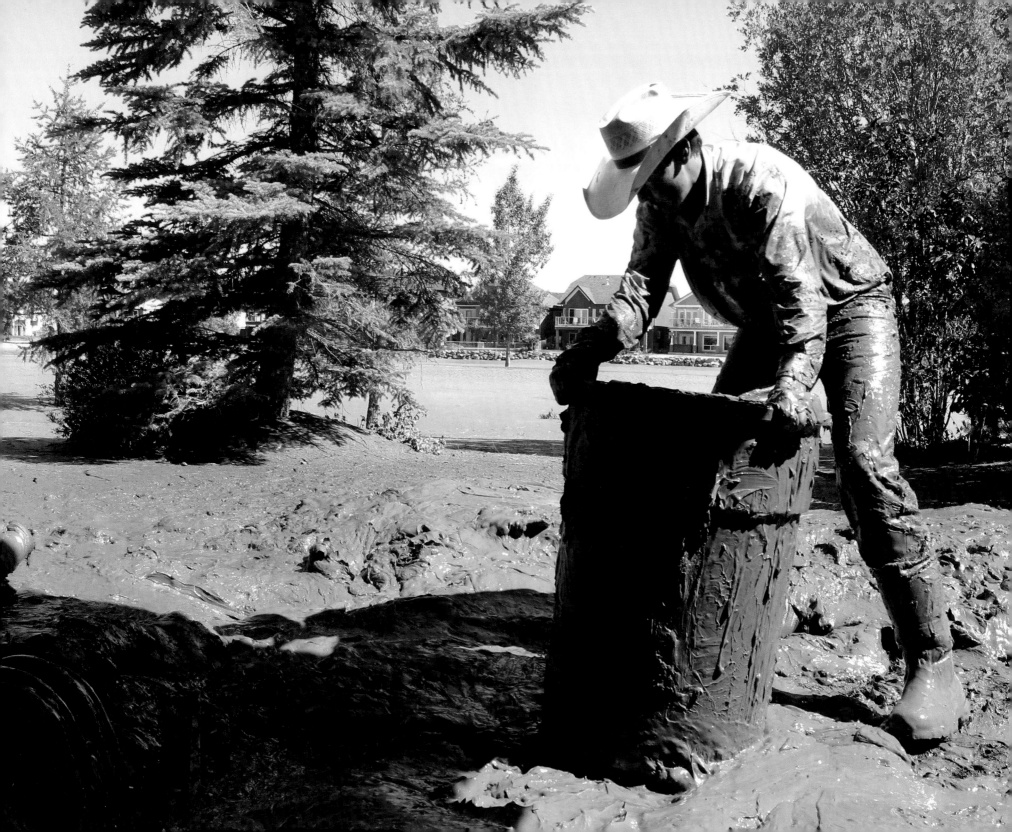

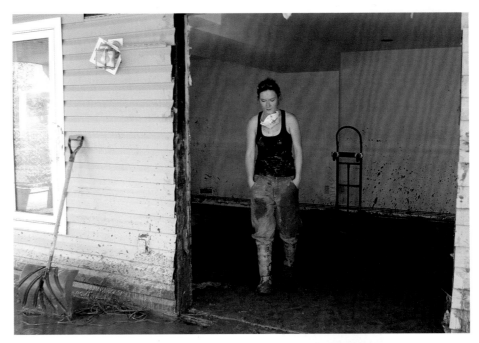

TOP RIGHT Kaliegh Stagg walked out of the High River basement she used to call home, after volunteers helped empty out its ruined contents. (Lorraine Hjalte/*Calgary Herald*)

BOTTOM RIGHT Keith and Barb Graham looked over the belongings that used to be in their High River basement in Sunshine Meadows. Barb noted the only thing that brought her to tears was the kindness of strangers who helped them clean. (Lorraine Hjalte/*Calgary Herald*)

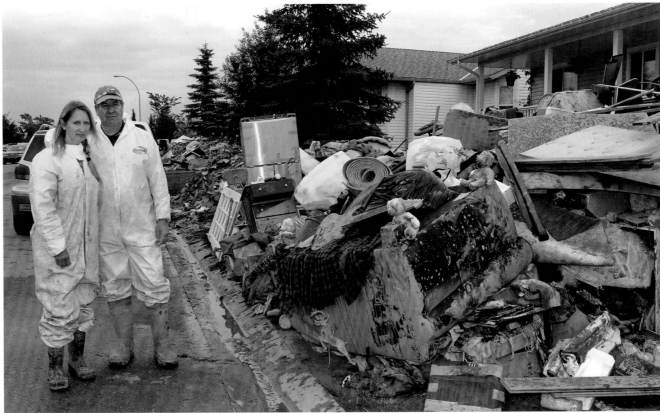

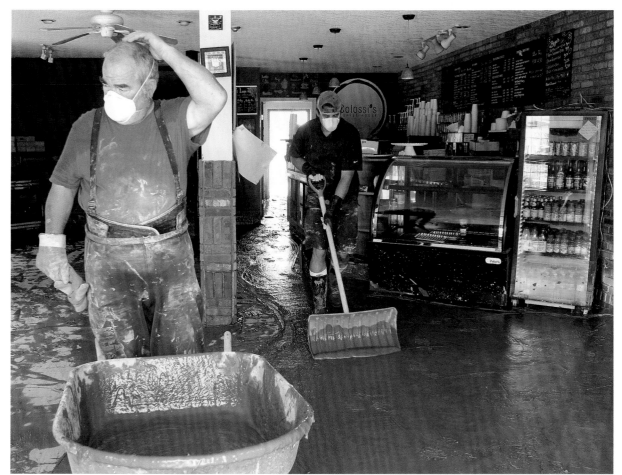

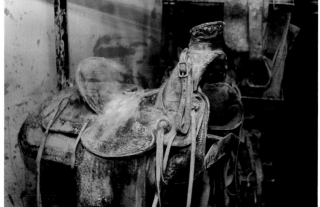

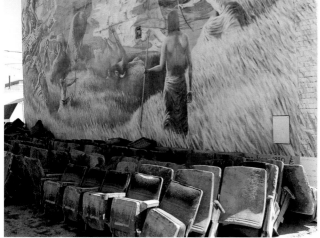

ABOVE LEFT Doug Elliott (left) and Dwayne Johnson shovelled out the mud left behind in Colossi's Coffee House in High River on July 1, after business owners were allowed back into their shops to clean up. (Lorraine Hjalte/*Calgary Herald*)

TOP RIGHT By July 9, this saddle was covered in mould in the storage space of the Museum of the Highwood, where 80 per cent of artifacts stored in the basement were lost to flood damage. (Lorraine Hjalte/*Calgary Herald*)

BOTTOM RIGHT Muddy seats were moved outside, under a mural, at the Wales Theatre in High River. (Lorraine Hjalte/*Calgary Herald*)

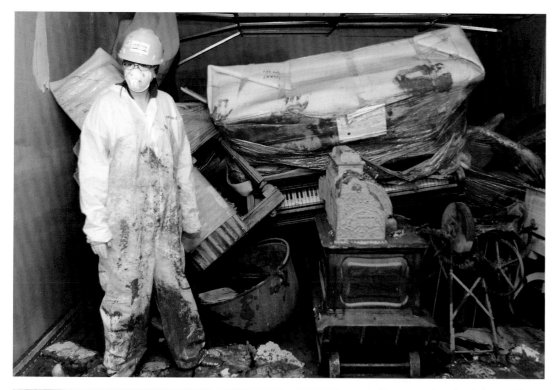

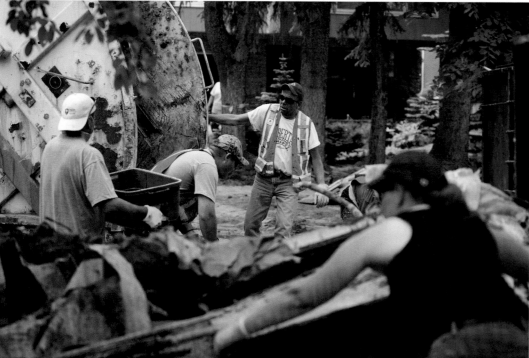

FACING PAGE Water was pumped out for weeks from some flooded areas of High River. (Trevor Scott Howell/*Calgary Herald*)

TOP LEFT Irene Cornwall, a summer student with the Museum of the Highwood, stood in front of two pianos that floated up in the water and eventually landed on top of a pile of artifacts.
(Lorraine Hjalte/*Calgary Herald*)

BOTTOM LEFT The cleanup at times seemed endless, but no one gave up, as volunteers in the High River community of Riverdale showed here on June 29.
(Tijana Martin/*Calgary Herald*)

TOP RIGHT While cleanup occurred in some parts of High River, other parts were still under water more than a week after the flood. A giant lake formed behind the Hampton Hills neighbourhood, where no water sat before June 20. (Lorraine Hjalte/*Calgary Herald*)

BOTTOM RIGHT This photo demonstrated how severe the problems were in High River, even two weeks after the flood. (Trevor Scott Howell/*Calgary Herald*)

FACING PAGE TOP LEFT Those evacuated from their homes for at least a week were eligible to receive a $1,250 pre-loaded debit card from the province. With many High River evacuees receiving temporary shelter in Nanton, it took more than five hours for some people to receive the cards in that community.

(Lorraine Hjalte/*Calgary Herald*)

FACING PAGE TOP RIGHT The Canadian Red Cross set up centres in three locations in Calgary so that people such as Judy Barabas (left) and Isdvan Barabas could pick up the debit cards.

(Tijana Martin/*Calgary Herald*)

FACING PAGE BOTTOM LEFT There was a substantial number of evacuees from care homes and senior housing facilities who were moved into various temporary shelters until their homes were declared safe. Trinity Place Foundation resident Shirley Churchill sat outside the Acadia Recreation evacuation centre with her belongings as she waited for a transfer to a new temporary shelter at Olds College on June 28. (Gavin Young/*Calgary Herald*)

FACING PAGE BOTTOM RIGHT High River residents picked up free beds, donated by McInnis & Holloway, one of hundreds of businesses that helped in any way they could.

(Tijana Martin/*Calgary Herald*)

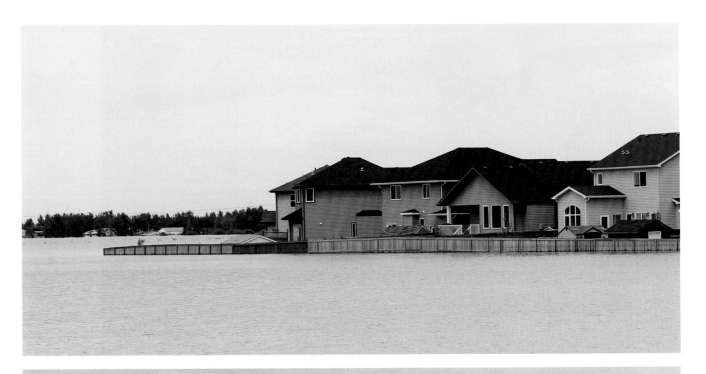

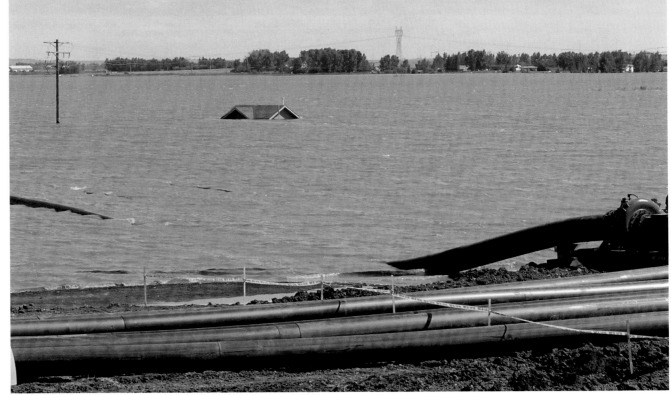

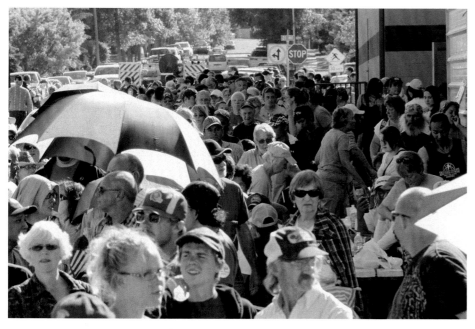
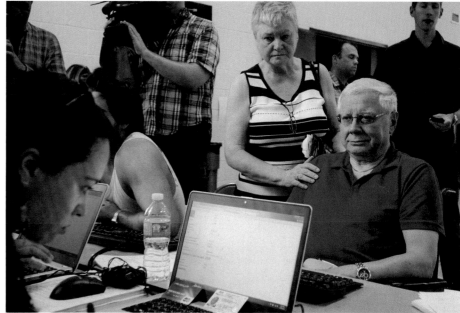
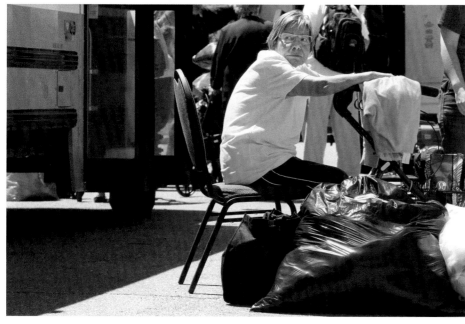

TOP RIGHT Residents were told to place signs in their windows that indicated what services they needed.

(Lorraine Hjalte/*Calgary Herald*)

BOTTOM RIGHT Calgary homes were being condemned within a week of the flood, as this sign on a Bowness house showed on June 28.

(Stuart Gradon/*Calgary Herald*)

FACING PAGE As the cleanup continued and some people tried to get back to normal routines, signs of life pre-flood began to appear. A few flowers pushed their way through the dried mud left behind by the flood waters in High River.

(Lorraine Hjalte/*Calgary Herald*)

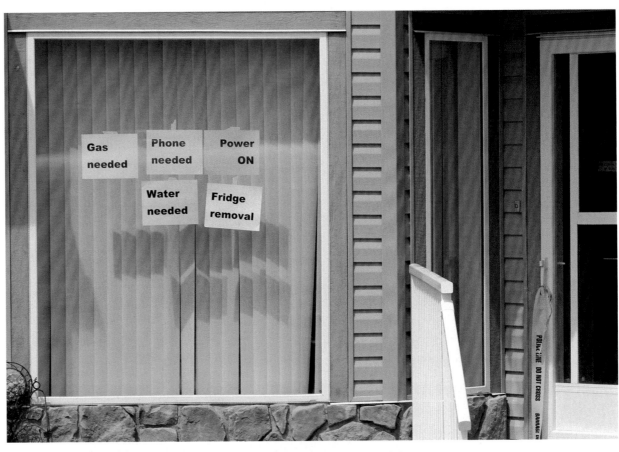

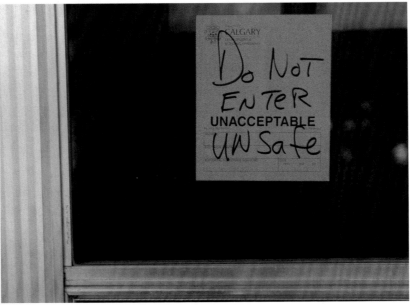

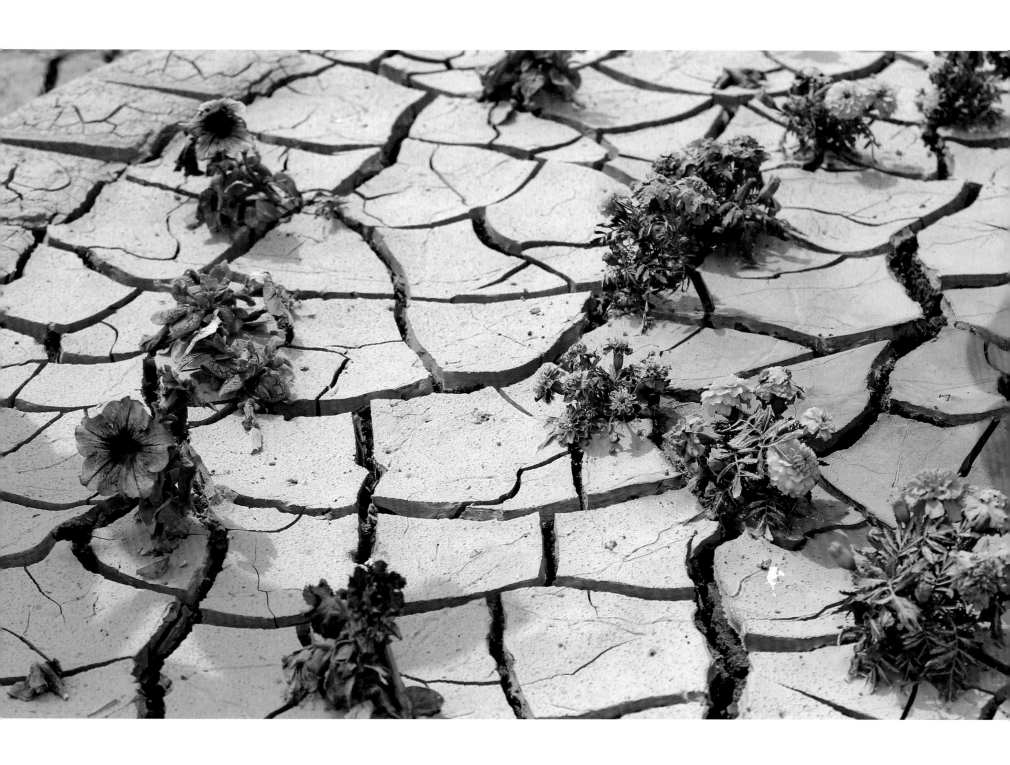

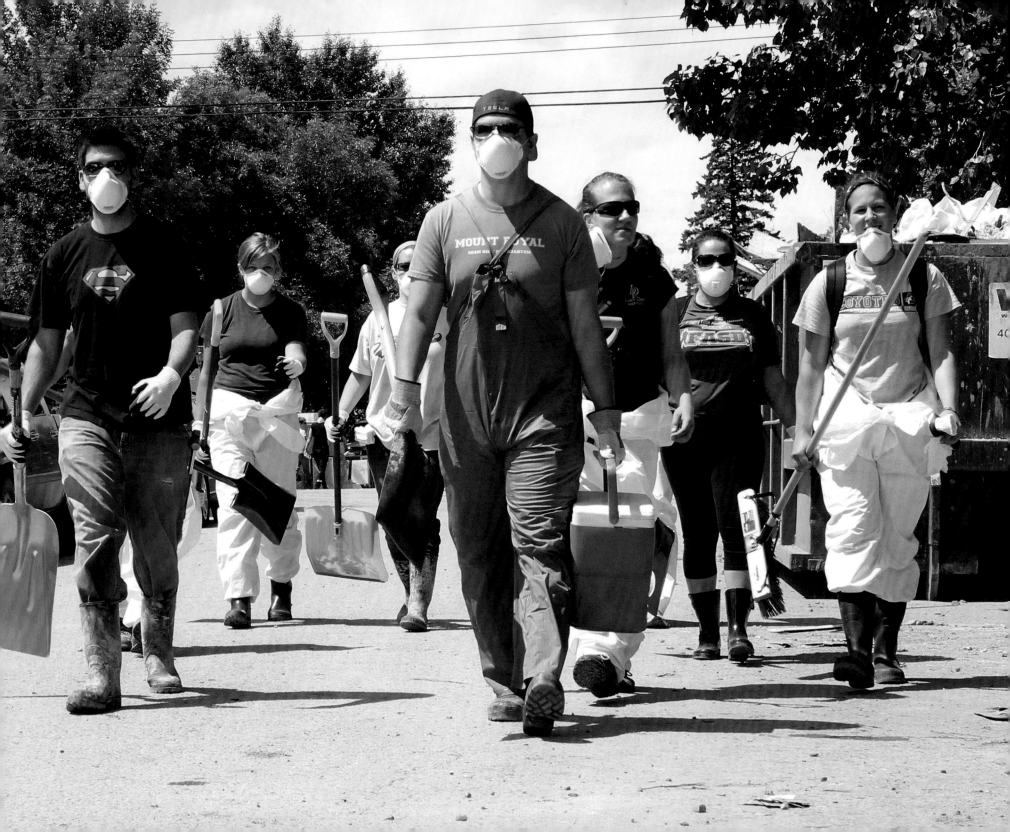

CALGARY HERALD

OUTSTANDING CALGARY AND INTERNATIONAL CORPORATE PHILANTHROPIST 2012-13

BREAKING NEWS AT CALGARYHERALD.COM PROUDLY CALGARY SINCE 1883 • MONDAY, JULY 1, 2013

THE FLOOD OF 2013

Calgary opens arms

Evacuated families affected by the flood line up in the heat Sunday at Connaught School to receive their pre-loaded debit cards.

City to build camp for High River evacuees

CLARA HO
CALGARY HERALD

As more High River residents prepare to return home Monday, the city announced a site is being set up in southeast Calgary for evacuees needing temporary housing while their flood-ravaged town undergoes recovery and reconstruction.

The City of Calgary was asked by the province to provide land with access to water, sewer and electricity for up to 1,000 High River residents.

"We're opening our city and our arms to displaced residents," Mayor Naheed Nenshi told reporters Sunday night.

Construction of the site started Saturday in southeast Calgary's Great Plains industrial area, and it will be done over the next two weeks.

The temporary accommodation facility in Calgary will also be open to evacuees from Kananaskis, Canmore and even Calgary who were displaced by floods, said Shane Schreiber, director of the High River task force that is helping residents get back in their homes.

The University of Lethbridge is also temporarily housing some High River residents, and another site near the Cargill meat-packing plant is being considered, Schreiber said.

He said the goal of these facilities is to get people out of evacuation centres in the area, including in Nanton and Blackie.

"We'd like to move people off the cots in those evacuation centres and into better, more comfortable housing," he said.

SEE CAMP, PAGE A2

COVERAGE INSIDE

A CHANCE TO HEAL
ACCESS TO HOMES EASES TENSION IN HIGH RIVER
Valerie Fortney, Page A6

MORE RELIEF COMING
PROVINCE TO ALLOW APPLICATIONS FOR RELIEF TUESDAY
Page A3

Follow us online: Get the latest updates on the flood situation. Also, watch for live chats offering breaking information
CALGARYHERALD.COM

Christina Metters prepares for Canada Day celebrations at Fort Calgary. Events have been moved this year from Prince's Island Park. Take our Canada Day quiz on Page D3.

RETURN TO HIGH RIVER
'GREAT PROGRESS' BEING MADE IN GETTING MORE EVACUEES BACK TO THEIR HOMES
Page A4

Thanks, Betty and Carl Powell, for being loyal Herald subscribers!
The Calgary Herald is proud to be part of the community and we appreciate the support of our readers and advertisers.

Show will go on for Canada Day celebrations

DAVID FRASER
CALGARY HERALD

Flood damage won't stop Albertans from celebrating Canada Day.

Each year, more than 100,000 people attend July 1 festivities in Calgary, and the city doesn't expect this year to be any different.

"We know many people, especially children, look forward to our Canada Day celebrations

every year, and I am happy to say that despite the ongoing crisis, we will not disappoint them," Mayor Naheed Nenshi said. "Although the event has been scaled down, I believe it will act as a huge example of our resiliency and celebrate our spirit of volunteerism."

Because of dangerous conditions near the Bow River, the celebrations won't take place at the usual spot, Prince's Island Park.

Instead, there will be food, music and entertainment at three locations: Shaw Millennium Park from 10 a.m. to 10 p.m.; Stephen Avenue Walk from 11 a.m. to 6 p.m.; and Olympic Plaza from 1 to 5 p.m.

"The opening of the downtown is a notable milestone in our recovery, and we certainly want to celebrate that, too," Nenshi said.

SEE CANADA, PAGE A3

Today 28°
Tonight 19°
Complete weather information
Full index on Page A2 Page A10

FACING PAGE Buses were organized to transport volunteers, such as these people, into High River to help clean up the devastation.

(Lorraine Hjalte/*Calgary Herald*)

4 / HELPING HANDS AND HEROES

THE FLOOD WATERS of 2013 may have washed away people's homes, businesses and vehicles, but rising to the surface was their undeniable spirit. Albertans faced this natural disaster head on, relying on mettle and magnanimity. Before the waters even receded, neighbours started helping neighbours and strangers began helping strangers. There were heroes on every corner, covered in mud, digging out neighbourhoods one shovel at a time. Communities came together like never before, through mud, sweat and tears.

TOP RIGHT Calgary mayor Naheed Nenshi addressed volunteers at McMahon Stadium before they headed out to help with the cleanup. He became one of the heroes of the flood, with a seemingly non-stop, straightforward and sensitive approach to disseminating information, assistance and reassurance. (Tijana Martin/*Calgary Herald*)

BOTTOM RIGHT During the first few days of the flood, Calgarians were urged to stay home because of traffic chaos—dozens of roads and bridges were flooded or damaged. However, on day five the official call went out for volunteers, and they were told to meet at McMahon Stadium. There were enough buses at the stadium to take six hundred volunteers to flood-stricken areas, but thousands of people turned out to lend a helping hand. Calgary's flood recovery had begun. (Tijana Martin/*Calgary Herald*)

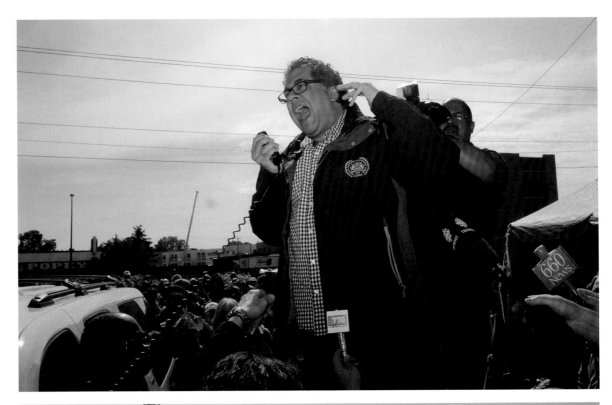

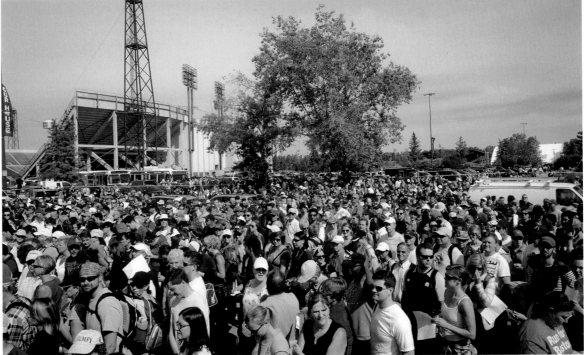

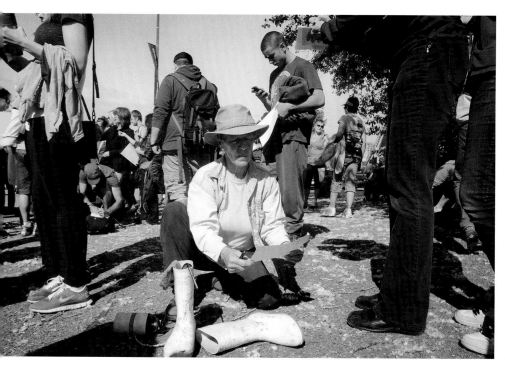

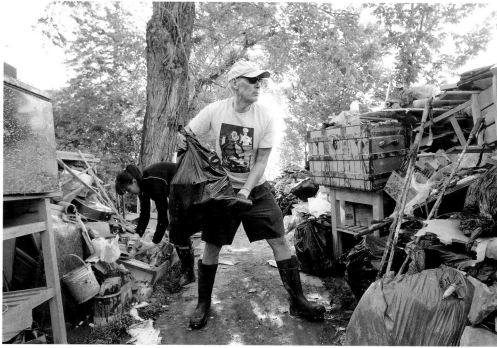

ABOVE LEFT Volunteers such as Elaine West patiently waited in line and filled out a form at McMahon Stadium before being transported to a flood-afflicted neighbourhood. (Tijana Martin/*Calgary Herald*)

ABOVE RIGHT Everyday citizens became heroes to their neighbours, donning rubber boots and shovelling tons of debris day after day. Wes Waddell helped remove rubbish from Calgary homes on Memorial Drive.

(Colleen De Neve/*Calgary Herald*)

TOP RIGHT Tens of thousands of unregistered volunteers were also making a difference across the city. Some would just show up in damaged neighbourhoods with a shovel and start cleaning up. Others organized their own flood relief efforts, such as Leisa Fuller (left). She and her friends collected more than $1,000 in change and then invited any flood victims or volunteers to visit the Wash House laundromat in Bankview and get their clothes washed for free. Here, Fuller helped volunteer Siobhan Troyer. (Gavin Young/*Calgary Herald*)

BOTTOM RIGHT Helping hands were also organized hands, as seen when volunteers Becky Rock (left) and Laura Robertson used a white board to keep track of cleanup in Calgary's Sunnyside community. (Ted Rhodes/*Calgary Herald*)

FACING PAGE There were countless stories of heroism from firefighters, police officers and emergency officials, whose quick actions in numerous situations prevented the injury and death toll from climbing. Officials here evacuated the Rideau area before flood waters covered the streets. (Colleen De Neve/*Calgary Herald*)

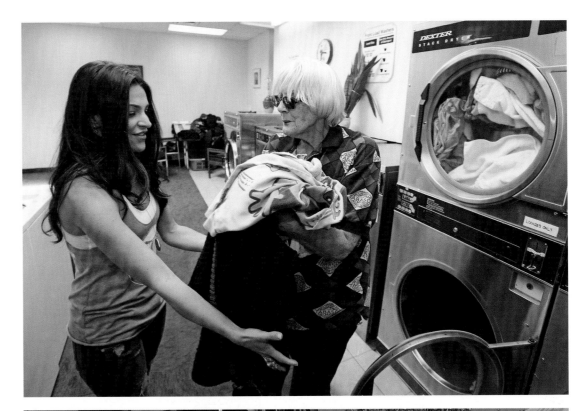

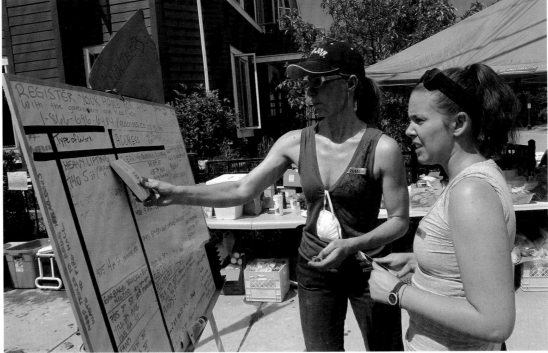

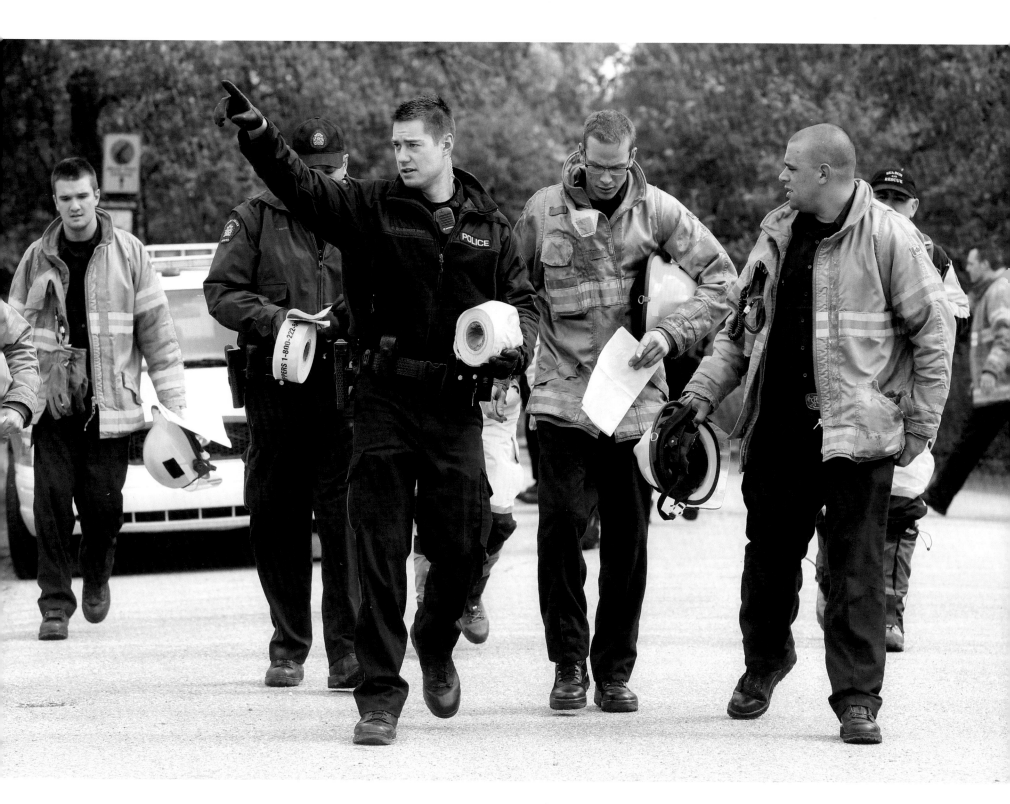

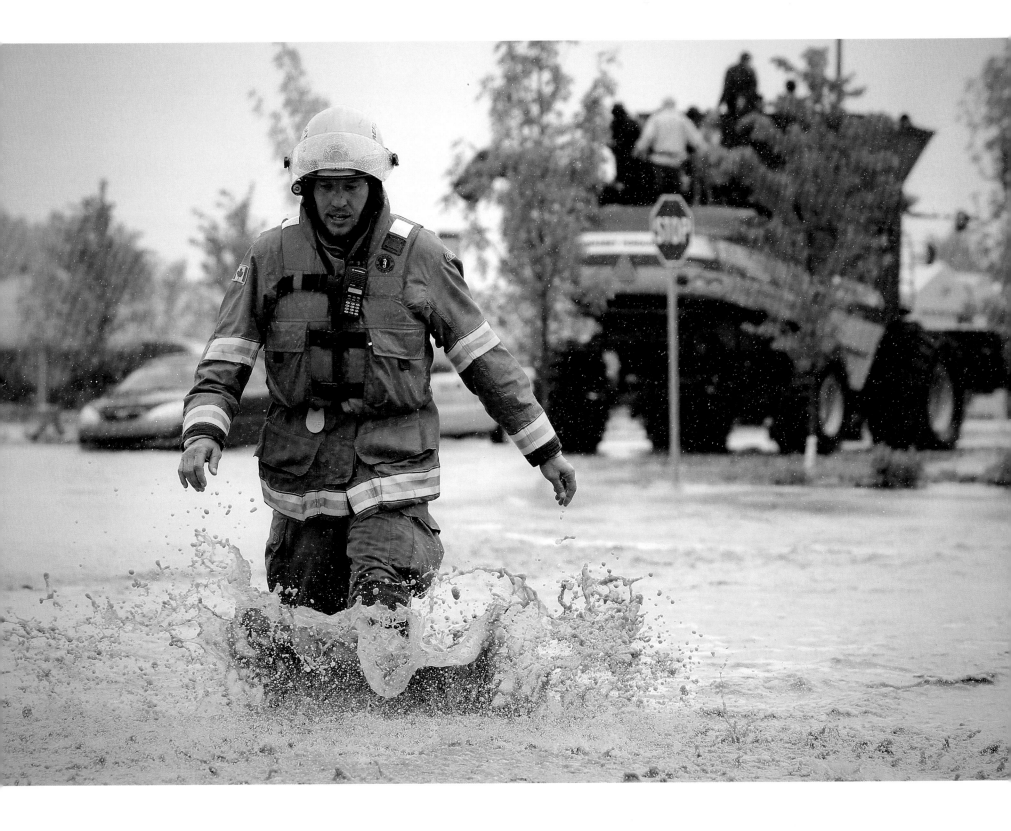

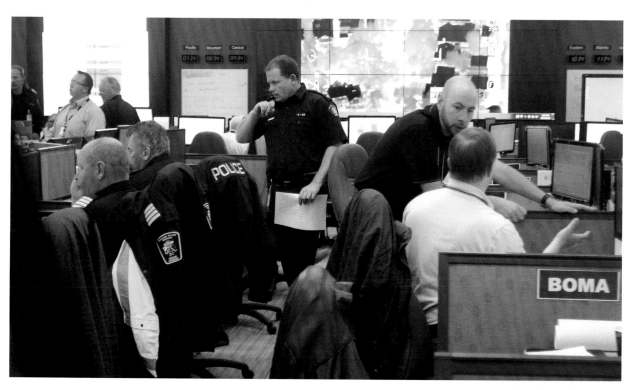

FACING PAGE Emergency personnel from numerous centres arrived in High River to deal with the natural disaster. A Nanton firefighter waded through flood waters to help rescue stranded people, while others were driven to safety on a combine. (Stuart Gradon/*Calgary Herald*)

TOP LEFT Emergency personnel, seen here near the height of the flood, worked non-stop at Calgary's Emergency Operations Centre to gain control of the situation. (Ted Rhodes/*Calgary Herald*)

BOTTOM LEFT Another hero who was praised for his efficient and effective actions was the director of the Calgary Emergency Management Agency, Bruce Burrell. His usual position is that of Calgary's fire chief. (Colleen De Neve/*Calgary Herald*)

TOP RIGHT Members of police and fire departments were often pitching in, shoulder to shoulder with volunteers. (Gavin Young/*Calgary Herald*)

BOTTOM RIGHT A sign in the Erlton neighbourhood thanked Calgary mayor Naheed Nenshi and the Calgary Police Service for their efficient response to the disaster. (Gavin Young/*Calgary Herald*)

FACING PAGE Although there were tens of thousands of volunteers in Calgary very quickly, it took a number of days until volunteers and residents were allowed into High River. Once the town opened up, thousands of people began flocking there to see what they could do. (Lorraine Hjalte/*Calgary Herald*)

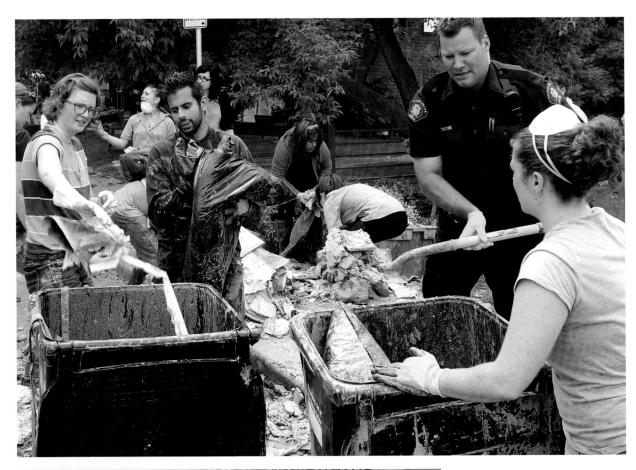

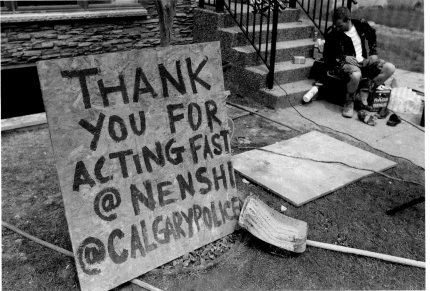

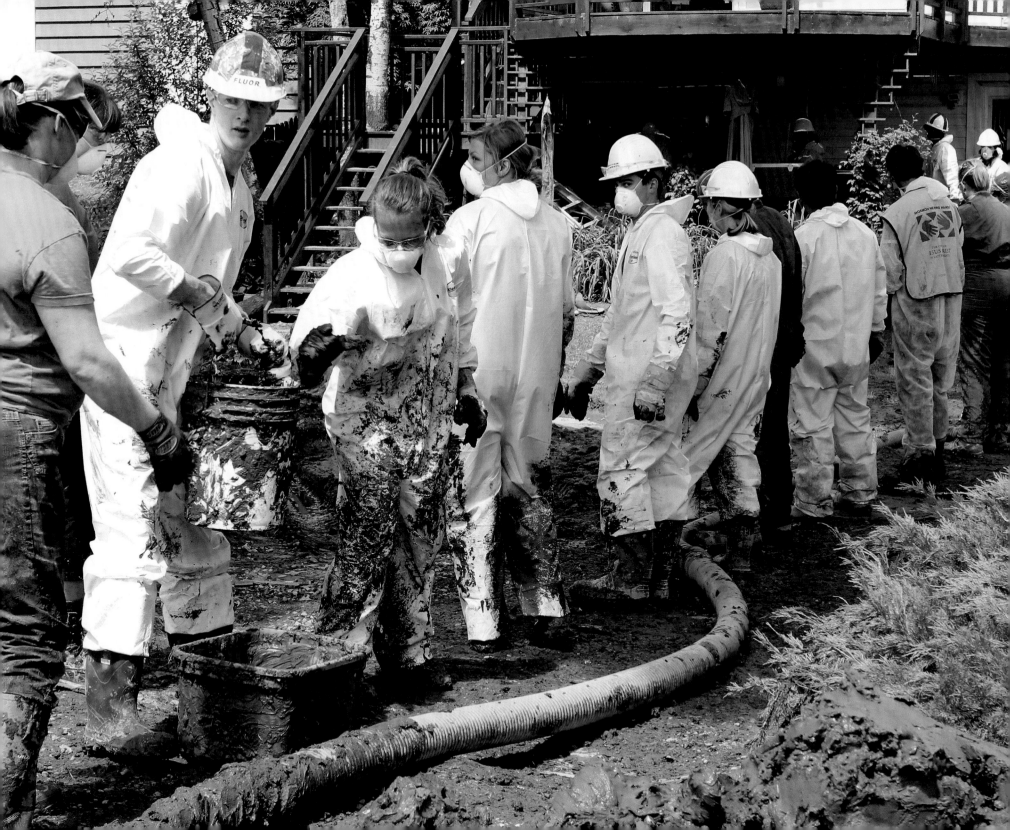

TOP RIGHT Volunteer Kathy Coutts worked to get as much dirt as possible out of a First World War jacket that was part of the collection in the Museum of the Highwood. (Lorraine Hjalte/*Calgary Herald*)

BOTTOM RIGHT A sign in the window of the Scout Hall in High River thanked volunteers. (Lorraine Hjalte/*Calgary Herald*)

FACING PAGE LEFT Dozens of aid groups, charitable organizations and religious congregations mobilized to help flood victims. Ashley Suitor volunteered at the Samaritan's Purse warehouse, putting together hygiene kits for flood victims in Calgary and surrounding areas. (Leah Hennel/*Calgary Herald*)

FACING PAGE RIGHT Albertans from across the entire province flocked to flood-ravaged areas to lend a hand, including this work crew from Slave Lake, Alberta Environment and Sustainable Resource Development. Front row, from left: Lance Orr and Kevin Willier; back row, from left: Joseph Bittman, Evan Orr, Cameron Girout and Blair Calahaisen. (Lorraine Hjalte/*Calgary Herald*)

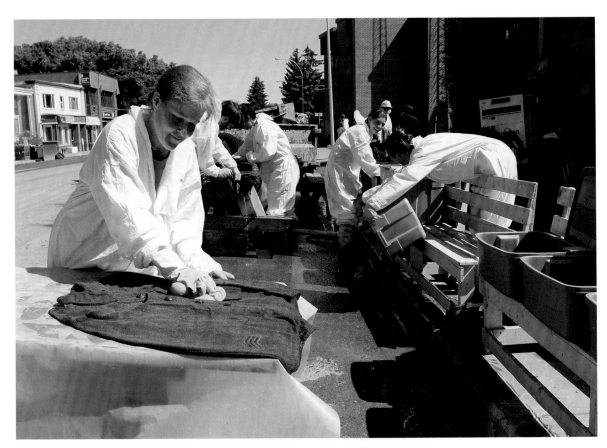

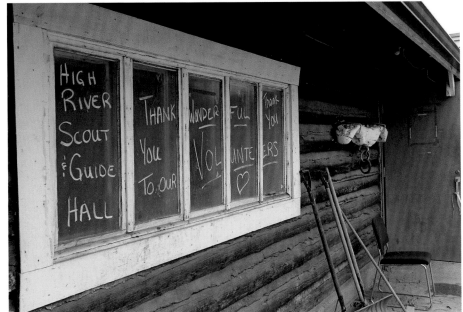

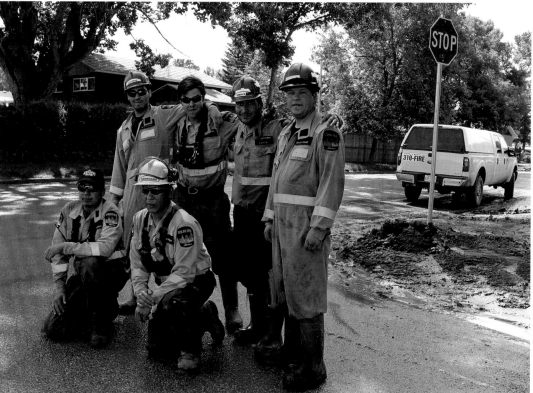

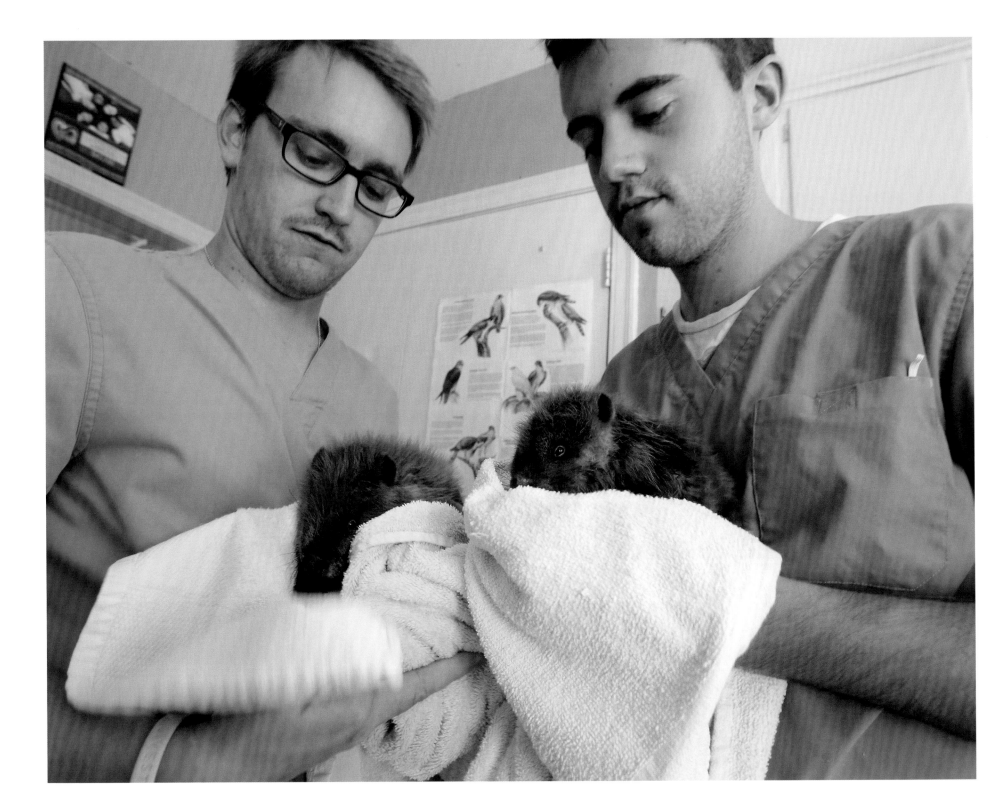

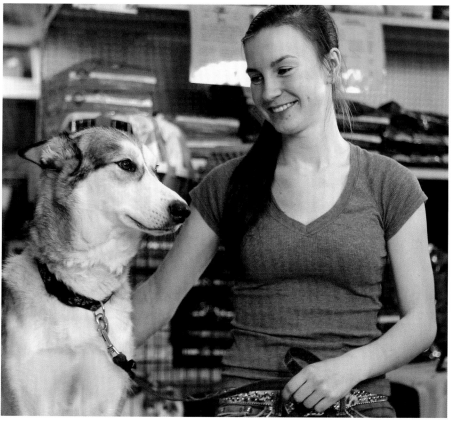

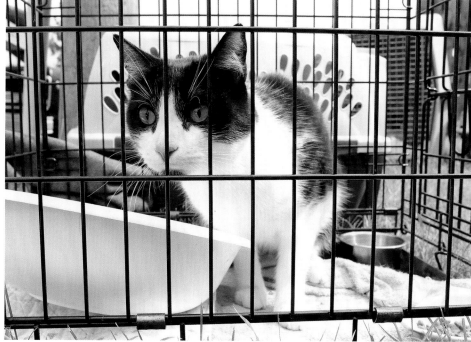

FACING PAGE It wasn't just people who needed help recovering from flood waters. Animal protection and animal care groups rallied to assist countless four-legged creatures. Wildlife technicians Ian Langill and Ross Watson held baby beavers Aspen and Birch, which were rescued from Bow River flood waters. (Gavin Young/*Calgary Herald*)

ABOVE LEFT Chanice Tarasoff took care of this dog, which was rescued and ultimately reunited with its owners at Cyndi's Pet Palace, in the hamlet of Cayley, Alberta. It was one of the facilities that took in more than eighteen hundred rescued animals from the High River flood. (Lorraine Hjalte/*Calgary Herald*)

ABOVE RIGHT This cat, rescued from High River, waited at Cyndi's Pet Palace for identification. (Lorraine Hjalte/*Calgary Herald*)

TOP RIGHT The High River rodeo grounds became a key location where volunteers registered to help.

(Gavin Young/*Calgary Herald*)

BOTTOM RIGHT Canadian Red Cross operations sprouted up across southern Alberta. The organization's Secretary General and CEO, Conrad Sauvé, looked over supplies outside the Hillhurst Sunnyside Community Association.

(Tijana Martin/*Calgary Herald*)

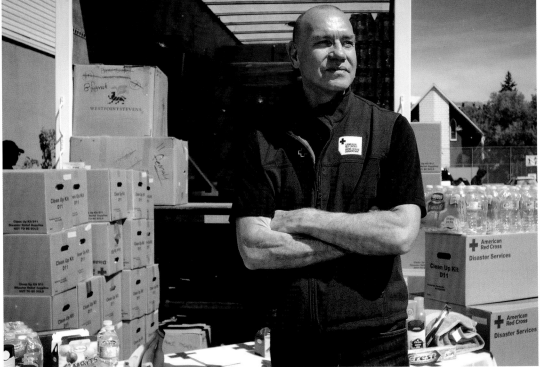

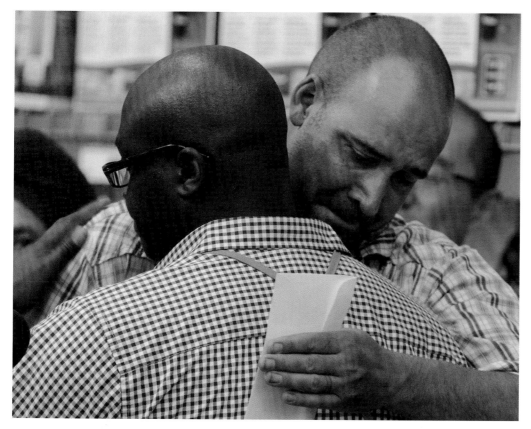

TOP LEFT The number of businesses that stepped up with heroic offers of shelter, supplies, equipment, water and food was too large to count. Mark Vazquez-MacKay was emotional as he hugged Calgary Home Depot manager Rob Hatton, who gave the Vazquez-MacKay family a $2,000 cheque to help rebuild their flood-damaged home. (Gavin Young/*Calgary Herald*)

BOTTOM LEFT Donations quickly flowed into High River; at the rodeo grounds, residents picked up flood relief supplies. (Gavin Young/*Calgary Herald*)

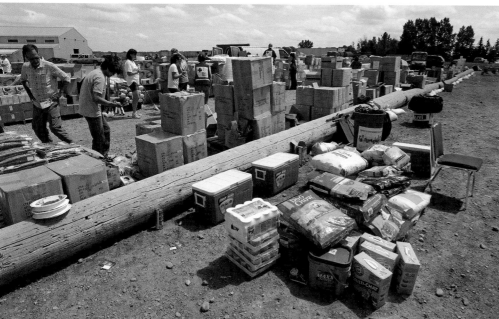

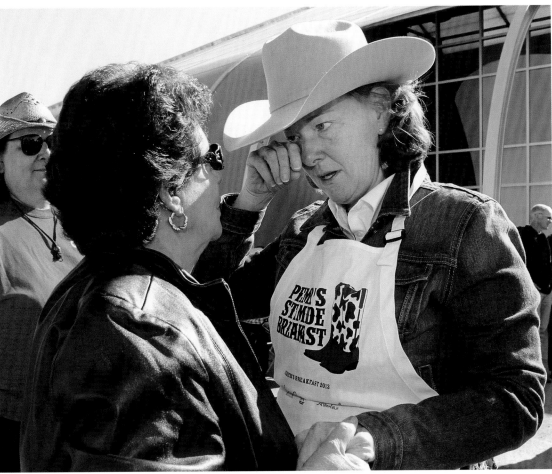

ABOVE LEFT Prime Minister Stephen Harper also got his hands dirty, hauling debris from flood-damaged homes in High River. Although he didn't tell media he would be working in the town, other volunteers snapped and shared photos of Harper. (Courtesy of Suzanne Motley)

ABOVE RIGHT Alberta premier Alison Redford was visible in flood zones throughout the disaster. She moved her usual Stampede breakfast from Calgary to Aldersyde, to be closer to those worst hit by the floods. She shed a tear at the breakfast while talking to family friend Pat Craige. (Lorraine Hjalte/Calgary Herald)

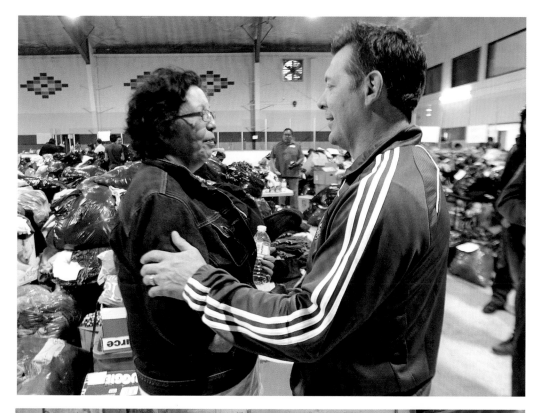

TOP LEFT Hockey heroes such as Lanny McDonald, Hayley Wickenheiser and Jim Peplinski were just a few of the professional athletes and Olympians spotted in Calgary helping with the cleanup. Volunteer Toni Good Eagle spoke with former NHL player Theoren Fleury after Fleury and his wife dropped off donations at the emergency evacuation centre at the Siksika reserve southeast of Calgary. More than a thousand of the roughly thirty-five hundred residents were affected by the flooding of the Bow River.

(Colleen De Neve/*Calgary Herald*)

BOTTOM LEFT Politicians from across the province and from Ottawa, such as opposition leader Justin Trudeau (in white coveralls), pitched in to help.

(Lorraine Hjalte/*Calgary Herald*)

TOP RIGHT The outpouring of support from people of all ages could be seen across the city, demonstrated by eleven-year-old Dawson Evans (left) and Aidan Laird, who brought food to volunteers and homeowners in Bowness.

(Leah Hennel/*Calgary Herald*)

BOTTOM RIGHT Volunteers from Our Lady of Assumption school in Bowness distributed food to many people cleaning up that community.

(Leah Hennel/*Calgary Herald*)

FACING PAGE Canadian country music artist Paul Brandt helped out at flood-damaged homes in High River.

(Stuart Gradon/*Calgary Herald*)

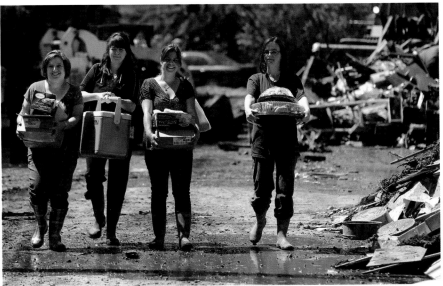

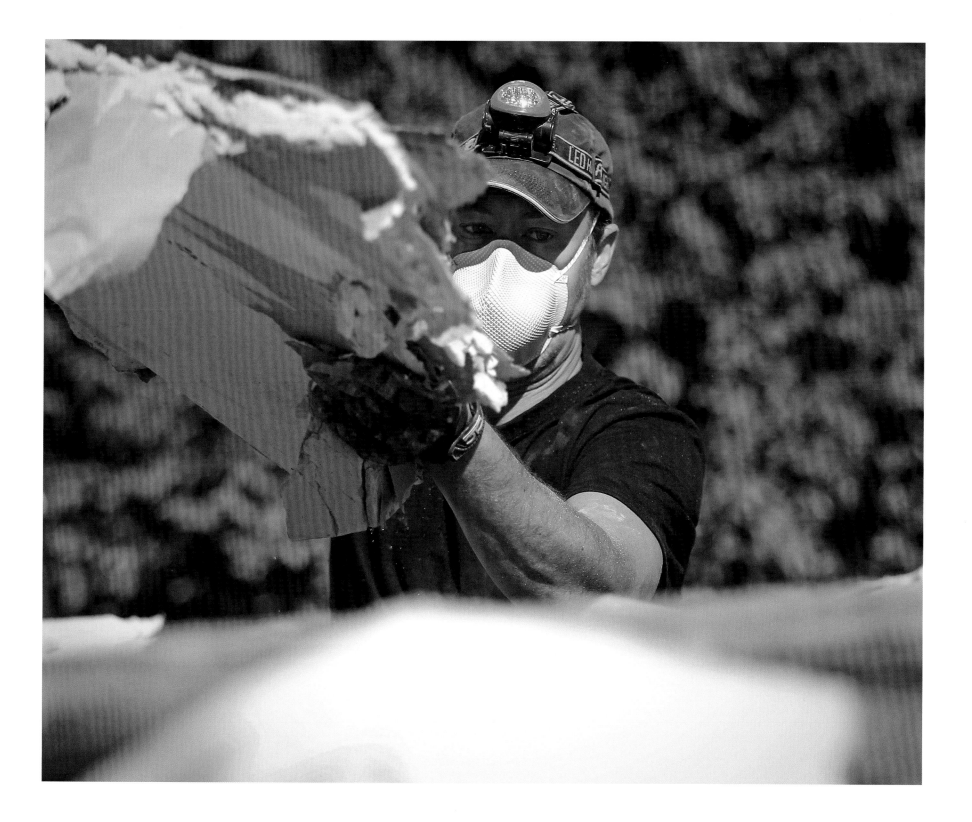

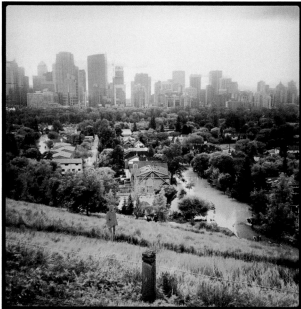

5 / HOW ALBERTANS SAW IT

FLOODING STRUCK PARTICULAR neighbourhoods and towns, but all of southern Alberta was affected by the disaster. Families and friends shared stories and photos of heartbreak and hope. Facebook pages and Twitter accounts were updated non-stop, and readers emailed countless photos to the *Calgary Herald*. Many of these compelling images ran in the paper and online at calgary herald.com. Here are just a few of the photos we can't forget.

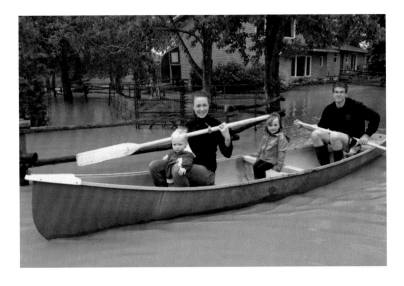

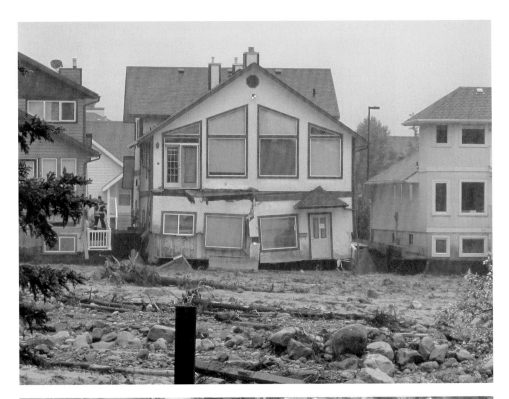

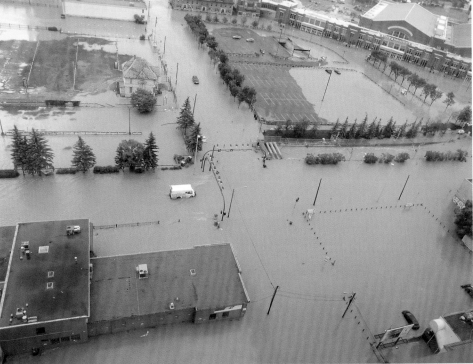

ABOVE Flooding necessitated new modes of transportation. This family explored in their canoe. (Nikayla Reize)

TOP RIGHT Damaged houses backing onto the swollen Cougar Creek in Canmore on June 20. (Anonymous reader)

BOTTOM RIGHT Victoria Park, near the Stampede grounds, was flooded by June 21. (Katrina Sriranpong)

FACING PAGE TOP A panoramic view of some of downtown's flooded streets on June 21. (Ryan Stearne)

FACING PAGE BOTTOM LEFT Sandy Beach was overrun with water on June 21. (Lisa Homer)

FACING PAGE BOTTOM RIGHT Kevin Altheim rescued a fawn from flood waters in Calgary. (Jim Sherwood)

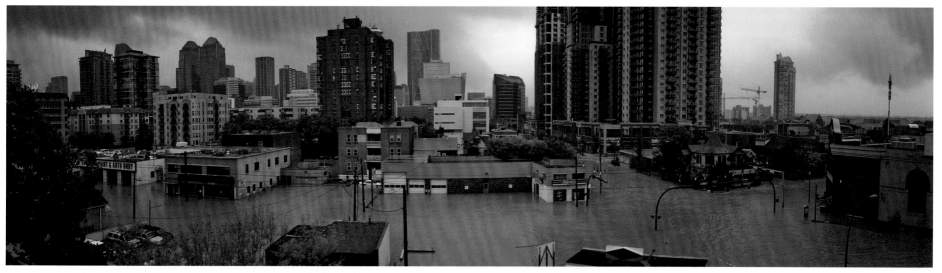

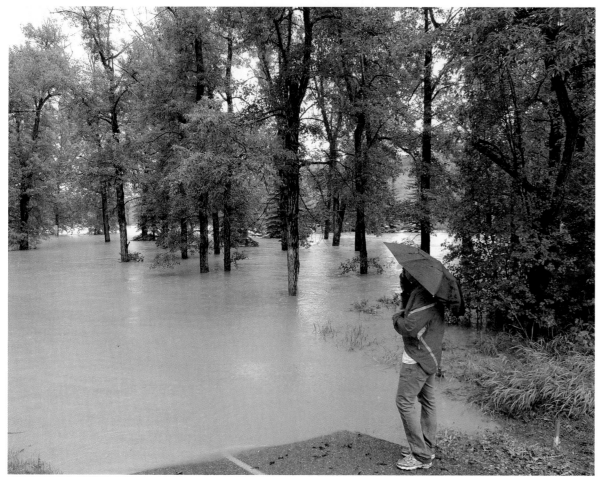

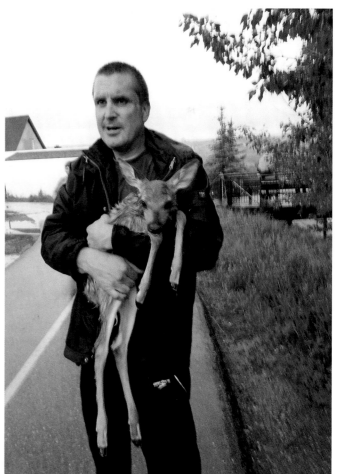

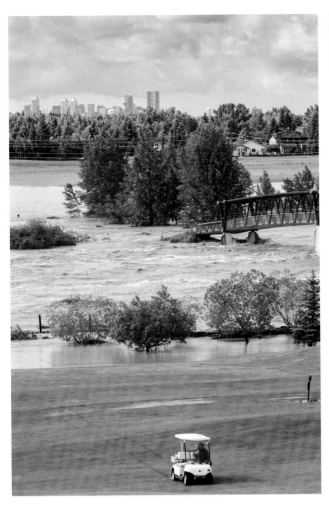

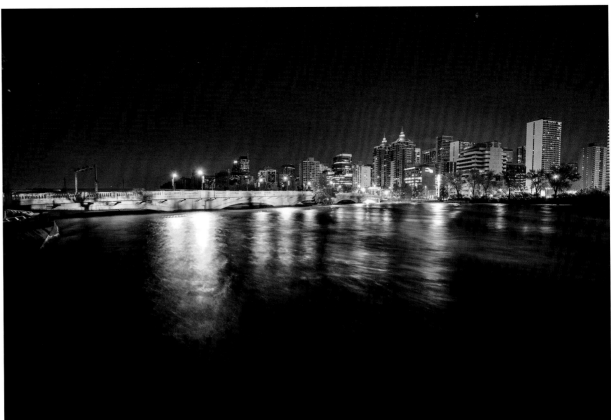

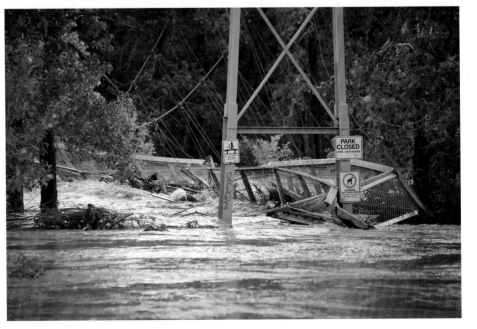

ABOVE The river surged ever closer to McKenzie Meadows Golf Course on June 21. (Jill Lassaline)

TOP RIGHT The Louise Bridge spans a swollen Bow River on June 22.
(Andrew Crossett)

BOTTOM RIGHT The pedestrian suspension bridge in Sandy Beach Park was destroyed. (Roy Gurel)

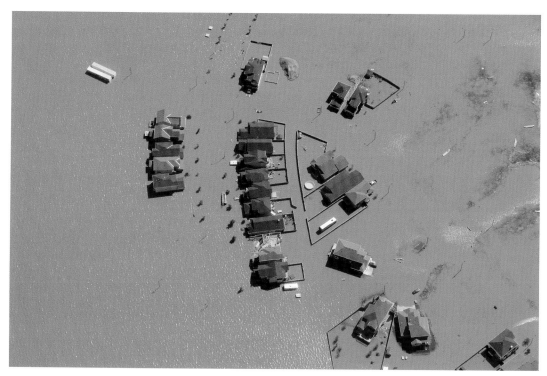

LEFT An aerial view of flooded High River homes on June 30. (Chris Gibson)

BOTTOM LEFT Downtown was a ghost town after it was evacuated. (Jesus Martin)

BOTTOM RIGHT Debris was caught up by trees under the 16th Avenue overpass on June 27. (Jill Vargo)

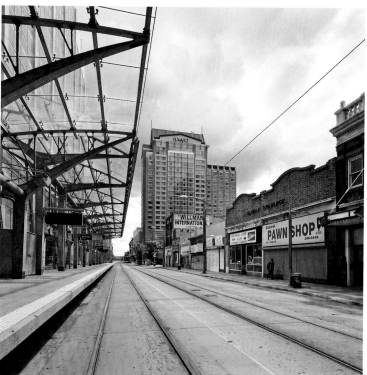

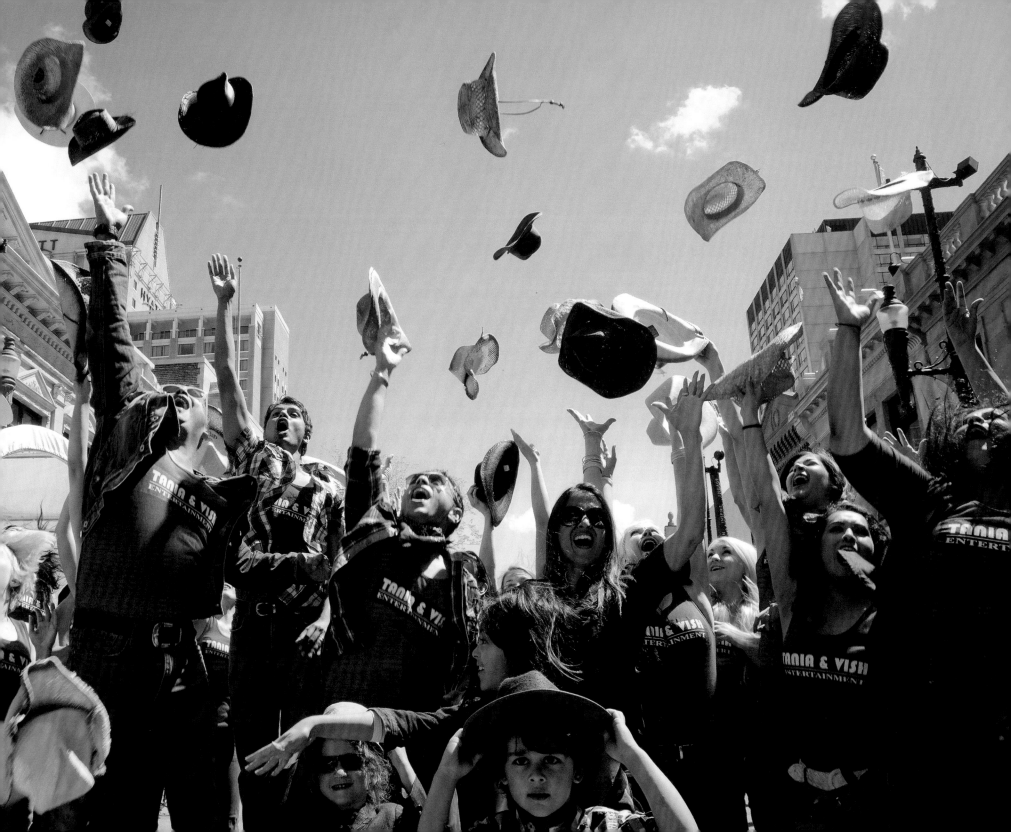

MEET THE
NEW FACES
OF THE
CALGARY
FLAMES
Sports, Pages F1, F3

TOWERING JOB
NEW LOOKOUT AT CALGARY AIRPORT, TALLEST OF ITS
KIND IN CANADA, PAVES WAY FOR PARALLEL RUNWAY
Calgary Business, Page E1

CALGARY HERALD

OUTSTANDING CALGARY AND INTERNATIONAL CORPORATE PHILANTHROPIST 2012-13

BREAKING NEWS AT CALGARYHERALD.COM PROUDLY CALGARY SINCE 1883 THURSDAY, JULY 4, 2013

Volunteers answer call

Hundreds of helpers rush to assist High River with recovery **PAGE A3**

THE FLOOD
OF 2013

STAMPEDE **EXTRA**: FIVE PAGES INSIDE

NENSHI PILOTS
CTRAIN AS
SOUTH LRT
LINE REOPENS
PAGE A6

HABITAT FOR
HUMANITY
TO RAMP UP
ASSISTANCE
PAGE A11

"We need to, more than ever, show the world how good our city is," says chuckwagon driver Jason Glass, at the Stampede barns Wednesday.
Colleen De Neve/Calgary Herald

High River native Jason Glass saw his share
of hardship when floods ravaged southern
Alberta. And while some might want to
quit, the chuckwagon champ says this year's
Stampede is a chance to show resilience
SEE VALERIE FORTNEY COLUMN, PAGE B1

MORE INSIDE
■ Parade ready to go,
route map inside B4
■ Floods won't halt
development plan B1
■ Take a peek at next
year's Stampede poster B3
■ Photographs reveal
extent of flooding B5
■ This year's must-dos
at the Stampede B5

OTHER STORIES

Thanks, H. Stephenson,
for being a loyal
Herald subscriber!
The Calgary Herald is proud
to be part of the community
and we appreciate the
support of our readers
and advertisers.

Today 23°
Tonight 11°
Complete
weather
information
Full index Page E12
on Page A2

EGYPTIANS
CELEBRATE
OUSTING OF
PRESIDENT
TOP NEWS, PAGE B10

BUSINESS
OWNERS SEE
SALES PLUNGE
IN FLOOD ZONE
PAGE E3

ZOO FORCED
TO LAY OFF
287 WORKERS
AS IT REBUILDS
PAGE A3

EDMONTON GIRL DIES AFTER
BEING LEFT IN CAR IN 30 C HEAT
THE WEST, PAGE A14

BODY OF
CLIMBER
RECOVERED
AFTER FALL
**CITY & REGION,
PAGE A15**

FACING PAGE Many Calgarians were happy
to celebrate their city's ability to rise above
circumstance and host a successful
Stampede, as seen by these flash mob
participants on a downtown street on July 13.

(Tijana Martin/*Calgary Herald*)

6 / HELL OR HIGH WATER

by VALERIE FORTNEY

C HRIS HADFIELD IS an out-of-this-world star, a guitar-strumming astronaut who connected with a new generation of space pioneers via social media from four hundred kilometres above Earth. On the morning of July 5, 2013, however, Hadfield's feet were firmly planted on the ground—the soggy ground of southern Alberta, which was recovering from the flood of the century.

The first Canadian to walk in space and the first to command the International Space Station, Hadfield had agreed a few weeks earlier to be the Calgary Stampede parade marshal for 2013. He was

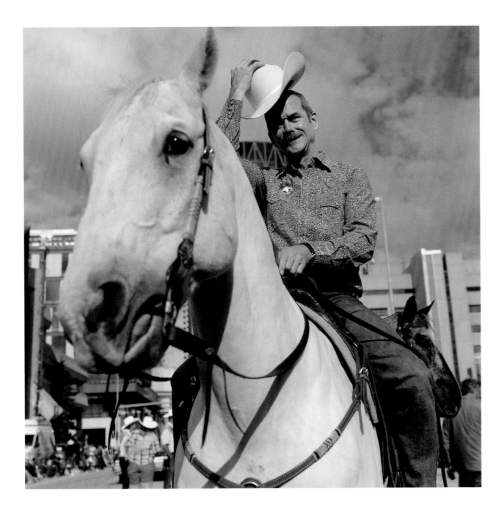

Parade marshal Canadian astronaut Chris Hadfield helped kick off the 2013 Calgary Stampede. The fact that the Stampede was able to go ahead on schedule was testament to Albertans' perseverance and ability to rise above the disastrous impacts of the flood.

(Leah Hennel/*Calgary Herald*)

trading in his spaceship for a horse named Jag and his flight gear for a white Smithbilt hat, along with maple-leaf emblazoned cowboy boots.

"You're going to grow up to be something," the space cowboy said to seven-year-old Simon O'Brien after shaking the child's hand on parade day. "So, you choose what it is you'll be and then get to work making it happen."

Such a simple axiom for life, offered by a national hero to a wide-eyed boy, provided a magical moment on the morning of the parade, as the Stampede marked its 101st year of existence. As a bright sun shone down on parade-goers and participants, Hadfield entertained the crowd waiting at the parade's starting point with such nuggets as "The Space Shuttle has 32 million horsepower—I think I can handle one horse."

Nearby, Calgary mayor Naheed Nenshi, his popularity now reaching galactic proportions, was receiving similar VIP treatment. "You've done a great job for this city," said Larissa Jahnke to Nenshi as he sat atop Garfield, the horse that had carried him through two earlier Stampede parades. "We're so proud of you."

Celebrating community has always been an integral part of the Calgary Stampede, those heady ten days of fun each July when one of the world's most forward-looking cities makes a rollicking return to its old cowboy roots.

This time, though, the celebration seemed more poignant and the gratitude was more effusive in a province that had bowed but didn't break. While local and visiting celebrities enjoyed their usual recognition, the 300,000 spectators lining the downtown route to cheer on the seven hundred horses and four thousand human participants reserved their biggest applause of the day for a new addition to the

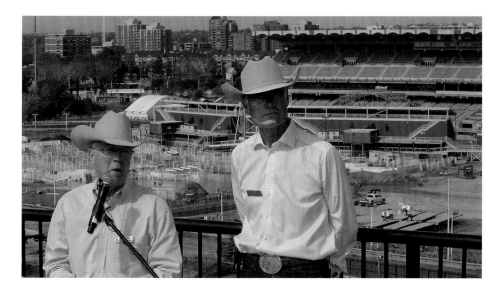

Calgary Stampede CEO Vern Kimball (left), with president and chairman Bob Thompson, promised Albertans that the Greatest Outdoor Show on Earth would go on, despite the flood damage at Stampede Park.

(Ted Rhodes/*Calgary Herald*)

parade: a group of men and women representing first responders, health care employees, city workers and so-called ordinary citizens who had spent the two weeks prior putting in eighteen-hour days to aid their fellow southern Albertans during the flood.

"The Spirit of our City and Province Cannot be Washed Away," read a banner carried by marchers in the opening hours of the Stampede—the iconic event that generates more than $340 million in local economic activity each year but, more importantly, trumpets Calgarians' civic pride to all four corners of the world.

This year's event was initially billed as "Stampede 101," a modest slogan that knew its place after the blowout centennial celebration of 2012. The year 2013 would be a nod to the beginning of a new century for the Stampede, as well as a reminder of the Western values that have been a mainstay since a wily American promoter by the name of Guy Weadick stormed into town in 1912 and staged a cowboy competition and homage to the Wild West the likes of which had never been seen before.

That was, however, before the most destructive flood in the province's history overtook many parts of southern Alberta, leaving five dead and more than 100,000 displaced in a span of less than twenty-four mind-boggling hours. Sitting a horseshoe's throw from the confluence of the Elbow and Bow Rivers, the sacred celebratory grounds of the Stampede were among the hardest hit by the raging torrent that ripped through the city's core and left tens of thousands of homes inundated with brown water and thick, slippery mud.

On the morning of June 21, Stampede officials could barely contemplate the damage wrought by flood waters that first came from the south to hit the grandstand and rodeo grounds, then doubled-back on a four-lane road to strike again from the north, damaging the Saddledome, home to local NHL team the Calgary Flames and the venue for big-name concerts during the Stampede and throughout the year.

As it was for homeowners and businesses for miles around, the devastation at the Stampede was heartbreaking. Most of the sixty-three buildings onsite were waterlogged. The Saddledome was filled past the eighth row of the lower bowl seating, as though someone had turned on a thousand taps and walked away. The rodeo infield was an inland sea two and a half metres high, thanks to the churning Elbow. The dirt track surrounding the infield was also

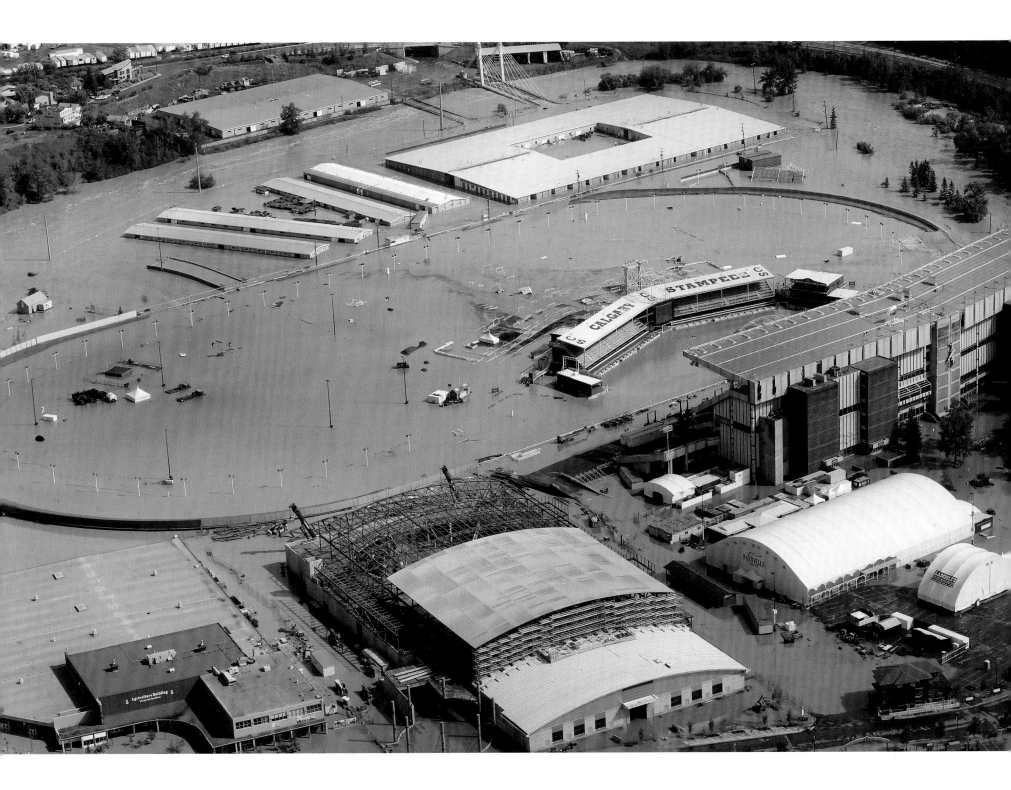

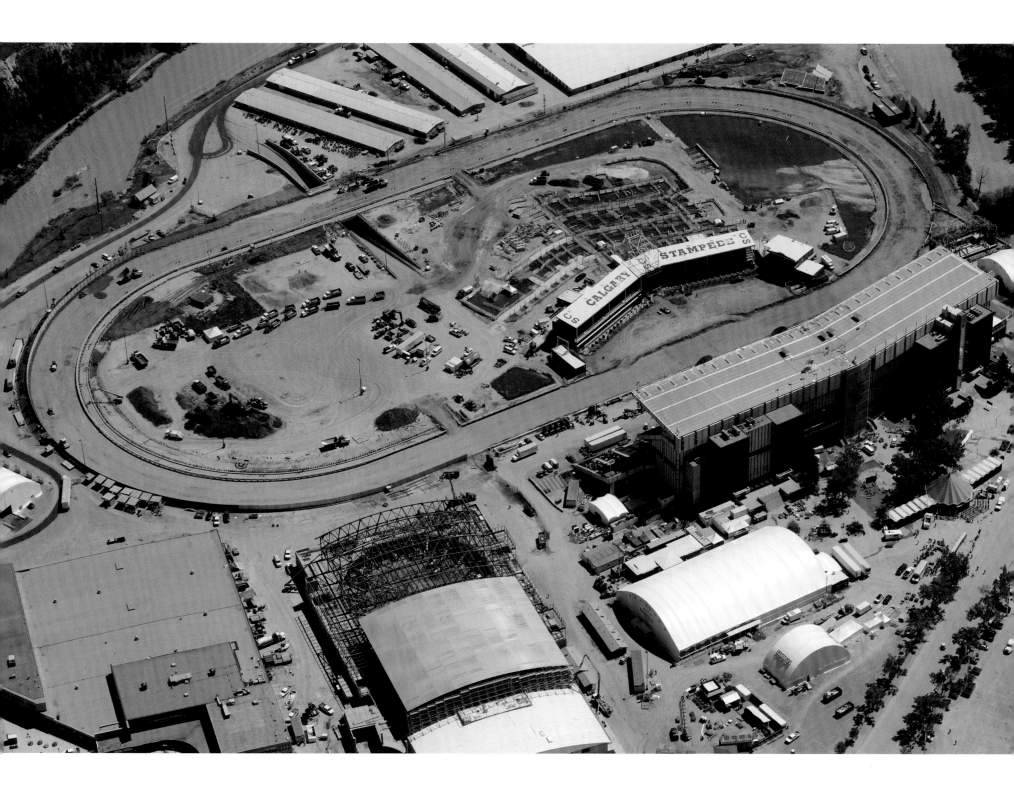

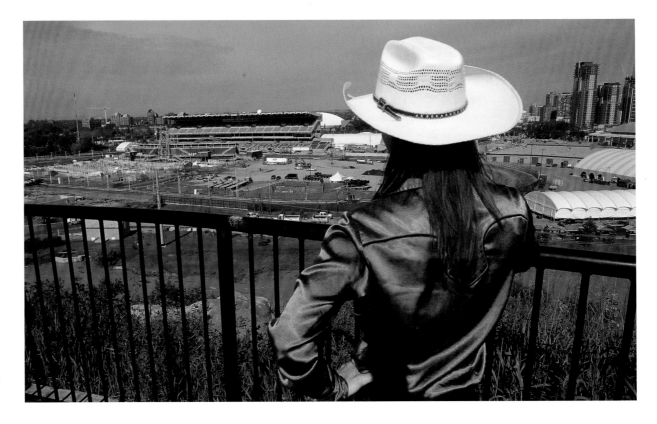

submerged, its long-time nickname Half-Mile of Hell taking on an even more ominous tone than usual. And the small town of horse barns tucked behind the track looked as though it was floating in a four-metre lake.

There was, however, one saving grace: the Stampede's electrical substation had been spared, leaving power to run the equipment vital to a cleanup that many predicted could take weeks or months.

Faced with such daunting odds, on June 24, Stampede president and chairman Bob Thompson stood on a balcony overlooking the grounds to boldly proclaim that the Stampede would indeed go on. "Throughout our entire history we have never cancelled a show, despite two wars and the Great Depression," said Thompson on a rainy day when military vehicles were patrolling city streets, soldiers were building berms, the downtown core was still without electricity and homeowners were starting the exhausting work of filling oversized dumpsters with drenched photo albums, mattresses and TV sets. "2013 will be no exception."

Some thought his words were admirable; others feared such an overly ambitious goal would siphon precious resources from a city and region struggling to emerge from under a crumbled infrastructure and the displacement of close to 100,000 citizens. To make good on the promise that the Stampede's cleanup would not put

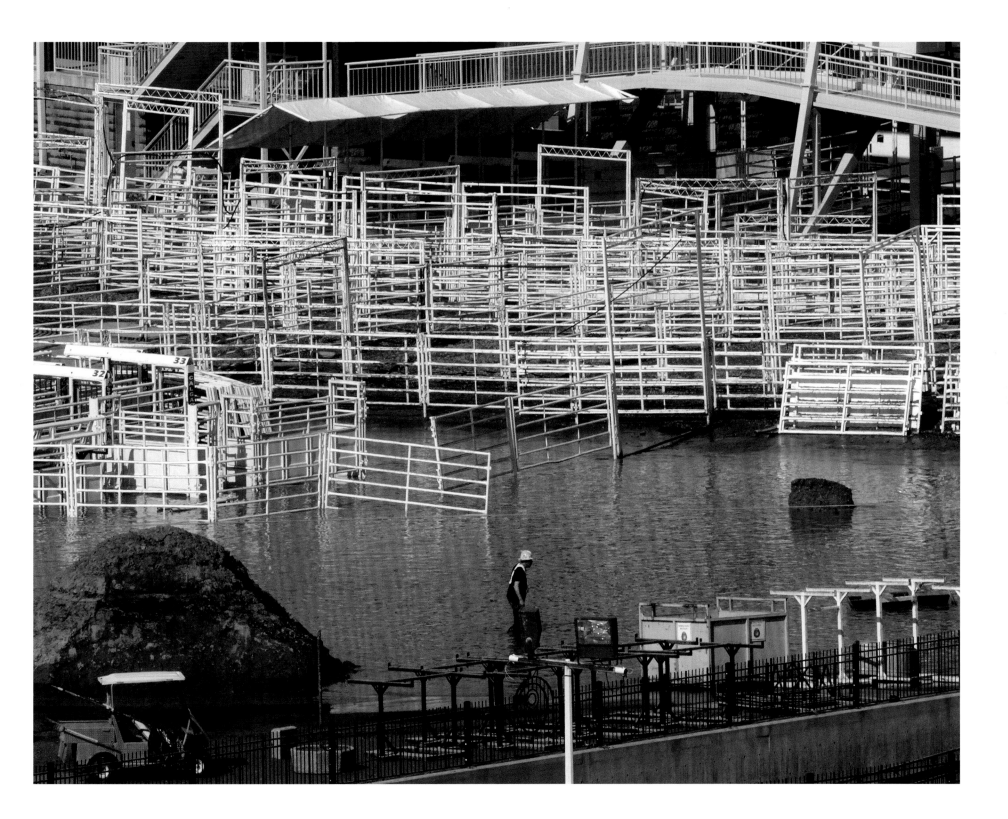

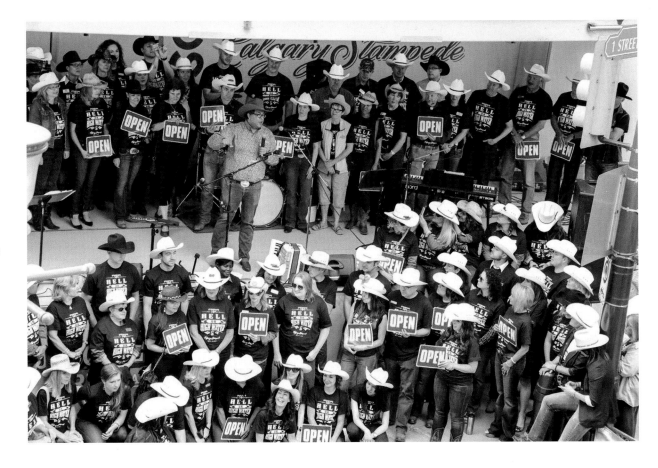

any additional strain on the city, Thompson and his team brought in North American experts in remediation—people who had experience with such disasters as Hurricane Katrina—and encouraged their army of more than twenty-three hundred volunteers to focus their efforts on helping neighbours struck by the flood. "We are greatest together and we will be hosting the Greatest Outdoor Show on Earth," said Thompson, employing the well-known Stampede slogan, before offering a new one that hearkened back to nineteenth-century cattle drives: "Come hell or high water."

By the eve of parade day, Calgary had lifted its state of emergency order and the Stampede was ready to welcome visitors to an event that would be scaled down in programming but bursting with defiant vitality. Some agricultural events were taken offsite, and a few buildings were only partially reopened. The racetrack, now with thirty thousand metres of new material, would be ready in time, but the Saddledome, despite being drained of 30 million gallons of water, was still months away from coming back to life. Without the Saddledome, there wasn't an appropriate venue to hold the Stampede's

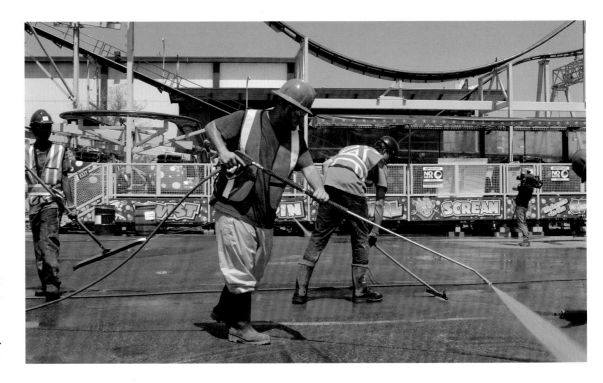

Three days before opening, workers were cleaning remaining river silt off the Stampede midway. (Gavin Young/Calgary Herald)

big-name concerts, and they were cancelled or postponed.

However, a never-say-die attitude caught like wildfire in a province determined to show the world that a natural disaster was no match for its collective strength and determination. The Stampede, which the late premier Peter Lougheed once described as "a way of life," had to go on, for both practical and symbolic reasons.

"You won't see Calgary at its prettiest," said Mayor Naheed Nenshi, borrowing a line he heard from a friend when talking about visitors who might have been contemplating a change in summer travel plans. "But you will see Calgary at its best."

Thompson's "hell or high water" phrase, which began on social media but was wisely co-opted by the Stampede organization, was emblazoned on T-shirts that raised more than $2 million for the Canadian Red Cross Alberta Floods Fund. The jubilant masses lining the five-kilometre parade route on July 5 were ready to not only party but also to thumb their noses at Mother Nature's wrath.

More than 1 million visitors made their way through the turnstiles of the Stampede to chow down on mini donuts, ride the new Mach 3 midway ride with its G-force of 3.6 and cheer on those indomitable cowboys and cowgirls. Each day, the crowds went wild for a stirring video tribute to the flood volunteers and first responders—everyday people who brought those long-lauded Western values to vivid life and reminded the world why Calgary came to be known as Volunteer City during the 1988 Winter Olympics.

Billy Melville was among the many heartened to see the "cowboy up" credo on full display. "You get the job done, no matter what adversity you face," said the chuckwagon historian. "Cowboys are always up to the challenge; they'll find a way."

That was how three-time world chuckwagon champion Jason Glass saw it on his twenty-fourth trip to the Stampede as a driver. "You have to wake up, shake it off and do what you need to do every time out," said the forty-two-year-old cowboy before going on to win

the $100,000 prize in the GMC Rangeland Derby. "We need, more than ever, to show the world how good our city is."

When the flood waters smashed into his hometown of High River on the morning of June 20, Glass was at the town's rodeo grounds, preparing for a pre-Stampede competition. The day, however, quickly turned into one of survival, for family members stranded in High River and for his horses. "It really hit home; it hurt friends, family, people I've known all my life," said Glass, a fourth-generation chuckwagon competitor. "Normally, (when racing) it's a 110–per cent focus on my horses. But this year, I felt a bigger cause—I wanted to put smiles on people's faces, give them something else to think about for a moment and make them proud of me."

By the start of the Stampede, Calgary was slowly getting back on its feet. Residents in many communities such as Sunnyside and Elbow Park still had handwritten signs in their living room windows, thanking volunteers and emergency workers for all their help. The dumpsters that had littered quiet avenues and cul de sacs were being hauled away, filled with the last bits of torn-out flooring and plaster.

"You see people with coolers of water, food trucks giving out burgers and pizza and guys who just show up and do hours of work without expecting a thank you," said Bowness resident Norm Ederle, whose lifetime home on the banks of the Bow had filled with water up to the main floor. "How often does something like that happen?"

Other southern Alberta communities were faring far worse. At Siksika Nation east of the city, where the water line came close to two hundred rooftops, hundreds of residents were still out of their homes with no timeline for returning. In High River, residents of entire communities were discovering that their homes were unfit for habitation. People in Canmore, Exshaw and Bragg Creek had yet to begin rebuilding their shattered homes.

Yet amidst the devastation, the best of humanity continued to shine through the darkness. Anil Karim, a resident of Calgary's Mission neighbourhood, transformed from a flood victim into a community leader. With his Mission Possible crew of more than two thousand local volunteers, he headed to outlying communities to continue the cleanup work he and his crew had begun during those early days in Calgary. The giving of time and energy was shared by people like John and Janette Mercer, among the countless southern Albertans who worked in makeshift corner cafes, handing out free food and drinks to volunteers in Calgary and, later, High River.

The extraordinary, so-called ordinary people were joined by former NHL star Theoren Fleury, who loaded up a truck filled with supplies he and wife, Jennifer, purchased for his friends at Siksika

FACING PAGE During the Stampede, there were plenty of moments to reflect on the impact of the flood. Cowboys removed their hats for the singing of "O Canada" before the daily rodeo on July 11. (*Ted Rhodes/Calgary Herald*)

LEFT High River, the hometown of chuckwagon driver Jason Glass, was hit hard by the flood, giving him added motivation in his ultimate win of the 2013 GMC Rangeland Derby at the Calgary Stampede. (*Stuart Gradon/Calgary Herald*)

The miraculous and profound mingled with the light and sometimes silly. We celebrated our mayor, a leader who throughout the crisis remained calm, capable and, best of all, communicative, with everything from a Nenshi pie created by local cookbook author Julie Van Rosendaal to a batch of T-shirts bearing his likeness. Those "There's a New Sheriff in Town" T-shirts raised money for flood relief, as did the "Keep Calm and Stampede On" buttons seen on urban cowboys and cowgirls at the many Stampede fundraising parties.

Many of those arriving for the Calgary Folk Music Festival at Prince's Island Park—only weeks after the venue was submerged in water—proudly wore their "Hell or High Water" T-shirts as they celebrated their city's renewal with song and dance.

The coffers of such charities as the Canadian Red Cross Alberta Floods Fund continued to fill up by the millions, thanks to donations

Nation; Prime Minister Stephen Harper and his wife, Laureen, spent an afternoon hauling soggy drywall from a High River home; and just a few blocks away, Liberal leader Justin Trudeau donned a white hazmat suit and shovelled mud for hours in the dank, dark cellar of a bungalow built around the time of the first Calgary Stampede.

Women from local Hutterite communities baked thousands of loaves of bread for evacuees stranded in nearby towns, and hundreds of volunteers with the Church of Jesus Christ of Latter-day Saints, as well as thousands of Samaritan's Purse volunteers, joined country music stars Paul Brandt and George Canyon as they swept and shovelled in High River and Siksika and Stoney Nakoda Nations.

from across the country. Canada's musicians rolled up their sleeves, too. The band Big Sugar held a fundraising concert in the city's southeast, and legendary rockers Rush—relocated from the drowned Saddledome to an arena in Red Deer—raised more than $500,000 for the Red Cross, with $125,000 of the funds going directly to the beleaguered town of High River.

Fears that the store of human kindness would soon be depleted were quickly proven premature. Two sold-out concerts raised money for the Calgary Foundation's Flood Rebuilding Fund, which supports all southern Alberta communities affected by the crisis.

For the country music lover, there was the Halo High Water concert and telethon on August 4, which saw such luminaries as Jim Cuddy, Michelle Wright and Paul Brandt share the stage at the Jubilee Auditorium. On August 15, the Alberta Flood Aid concert at McMahon Stadium hosted such big names as Nickelback, The Sheepdogs, Johnny Reid and Calgary's own Jann Arden. "It was so touching, on a personal level, on every level, how people came together to help each other," said Arden. Long-time Calgarian Leslie Feist donated the proceeds of her August 7 concert in Banff to the Calgary Drop-In Centre for flood relief.

The road ahead is long and arduous. Few were surprised when the province confirmed that the post-flood price tag could exceed $6 billion; a month after the disaster, the receding of the flood waters had been replaced by rising recovery tensions. The debate about how to mitigate future flooding continued, while victims in some of the hardest-hit communities were squaring off against the government, fighting for better compensation and an accounting of why entire developments were approved for flood-prone areas.

What many will remember best about the unprecedented summer of 2013, however, will be how Albertans' spirit overcame adversity and how the mud-splattered rubber boot was elevated to a status symbol. People will recall the stories of strangers who helped strangers and this region that would not let a deluge of water wash away its strength and determination. Albertans showed the world that they would not be defeated, that together they would face the challenges and not only survive but also ultimately thrive—come hell or high water.

For Chris Hadfield, the man who spent his life reaching for the stars and coming closer to them than just about any other human on the planet, that will be the lasting legacy of his visit to Calgary during its biggest annual celebration. "This year has been quite tragic for a lot of people," he said. "But at the same time, people endure... what really matters are the people and how we help each other."

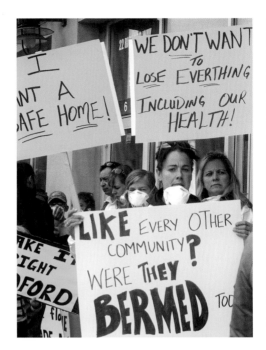

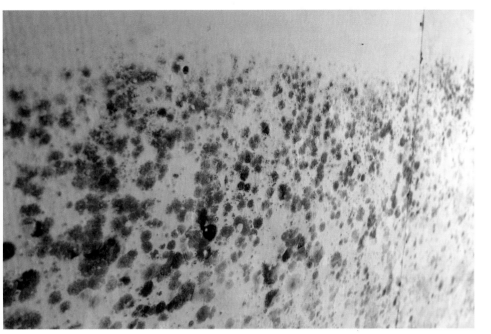

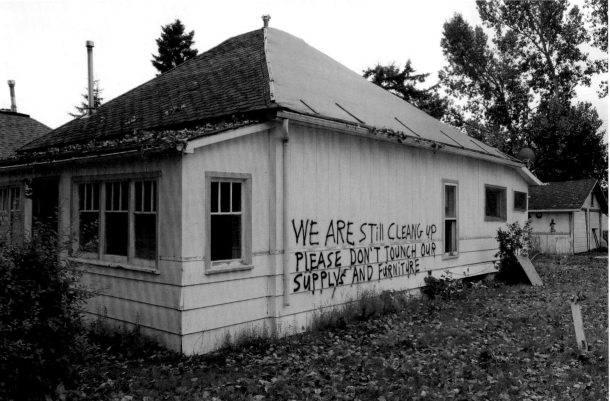

TOP LEFT Although several aid programs for flood victims were implemented, the massive destruction of the flood meant that not every problem had a perfect solution, leaving some people frustrated, confused and even angry. (Christina Ryan/*Calgary Herald*)

TOP RIGHT Mould was quick to grow on many household walls and surfaces, leading to many homes being condemned. (Gavin Young/*Calgary Herald*)

RIGHT Weeks after the flood, some High River residents were still trying to figure out how best to move forward with their homes. (Lorraine Hjalte/*Calgary Herald*)

TOP RIGHT High River resident John Labelle needed protective gear to enter and check out his home in the Hampton Hills neighbourhood. More than two dozen homes on his street were partially submerged for weeks after the flood, which led to many houses being declared unfit for habitation. Residents faced the difficult decision of whether to try to remediate their homes or abandon them. (Gavin Young/*Calgary Herald*)

BOTTOM RIGHT One of the first homes in High River that was destroyed by the flood was torn down on July 21.

(Lorraine Hjalte/*Calgary Herald*)

FACING PAGE Some flood victims would be without their homes for months, so temporary communities were constructed for them. Friends (from left to right) Ayen Coresis, age nine; Toni Aquino, age nine; and Kyal Ruiz, age ten, celebrated moving into new temporary housing in Saddlebrook, north of High River. (Lorraine Hjalte/*Calgary Herald*)

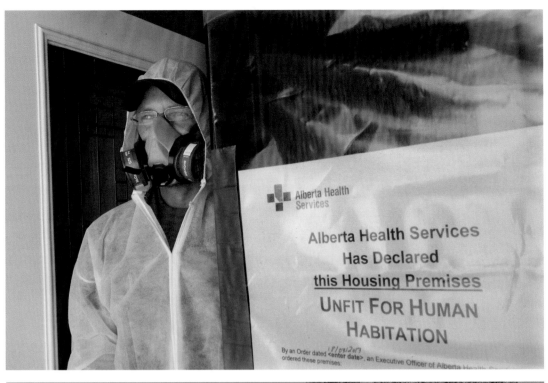

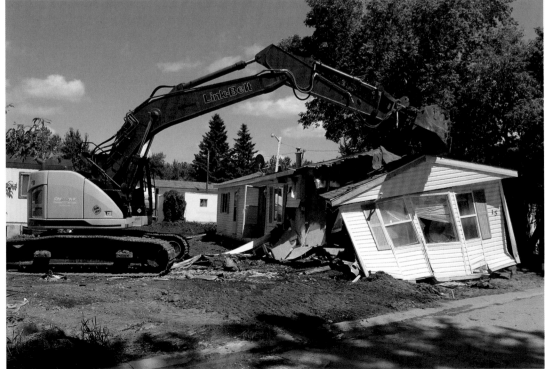

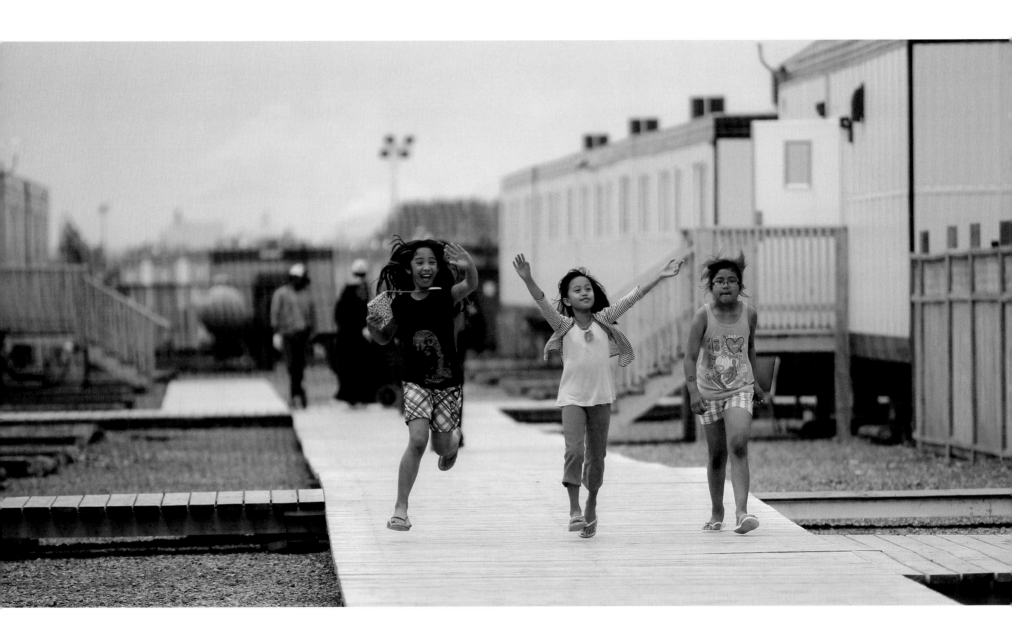

TOP RIGHT A highlight of the Halo High Water Flood Relief concert was a moving rendition of the song "Alberta Bound" by Paul Brandt, with background accompaniment by the Alberta Youth Choir. (Tijana Martin/*Calgary Herald*)

BOTTOM RIGHT Calgarian Jann Arden was a crowd favourite at Alberta Flood Aid. (Ted Rhodes/*Calgary Herald*)

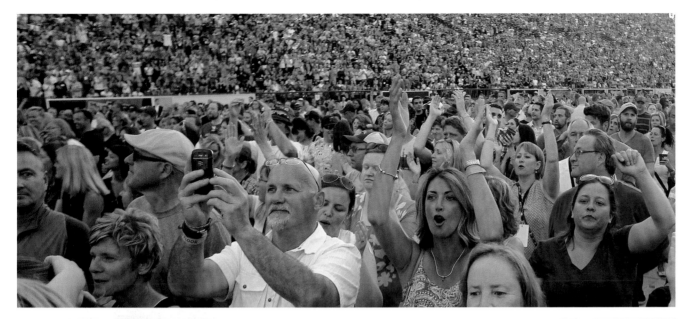

TOP LEFT More than thirty-two thousand people packed McMahon Stadium for Alberta Flood Aid. They cheered on Randy Bachman and his rock anthem "Taking Care of Business."

(Ted Rhodes/*Calgary Herald*)

BOTTOM LEFT At Alberta Flood Aid, a fan held up a rubber boot, symbolizing the incredible volunteer efforts seen during cleanup and Albertans' ability to fight back, rise up and come together.

(Ted Rhodes/*Calgary Herald*)

BEHIND THE HEADLINES

Dozens of *Calgary Herald* writers, editors, photographers, videographers and researchers—along with freelance journalists—worked on coverage of the 2013 floods. Their work was drawn upon, and used, within the pages of this book.

Karrie Atkinson
Tom Babin
Mike Bell
Valerie Berenyi
David Blackwell
Shelley Boettcher
Don Braid
Bill Brooks
Nora Bryan
Licia Corbella
Andrea Cox
Scott Crowson
Scott Cruickshank
Colleen De Neve
Colette Derworiz
Dianne Dickin
Jamie Dirom
Rick Donkers
Craig Douce
Wendy Dudley
Zoey Duncan

Stephen Ewart
Doug Ferguson
Eva Ferguson
Mike Fisher
Valerie Fortney
Tanya Foubert
Darren Francey
David Fraser
Tamara Gignac
Peter Glenn
Stuart Gradon
Jefferson Hagen
Vicki Hall
Paul Harvey
Dan Healing
Leah Hennel
Darcy Henton
Doug Hintz
Lorraine Hjalte
Clara Ho
Trevor Howell

Stephen Hunt
Michele Jarvie
Steve Jenkinson
Meghan Jessiman
George Johnson
Lisa Kadane
Charlene Kolesnik
Jamie Komarnicki
Naomi Lakritz
Wendy Leckie
Barbara Livingstone
Brody Mark
Jason Markusoff
Norma Marr
David Marsden
Tijana Martin
Stephane Massinon
Matt McClure
Rita Mingo
David Moll
Brent Morrison

Lorne Motley
Ruth Myles
Chris Nelson
Kristen Odland
David Parker
Debbie Penno
Karen Petkau
Meghan Potkins
Jeff Rankin
Ted Rhodes
Gwendolyn Richards
John Roe
Christina Ryan
Vicki Sand
Tony Seskus
Josh Skapin
Daryl Slade
Erika Stark
Natalie Stechyson
Amanda Stephenson
Mario Toneguzzi

Jason van Rassel
Chris Varcoe
Eric Volmers
Shelley Wallis
Bruce Weir
Bryan Weismiller
James Wood
Jennifer Worley
Deborah Yedlin
Claire Young
Gavin Young
Jamie Zachary
Sherri Zickefoose
Monica Zurowski

CALGARY HERALD